A Spectacular Vision:

The George

and Susan

Proskauer

Collection

Published 1994 by the University of Kentucky
Art Museum
Rose Street and Euclid Avenue
Lexington, Kentucky 40506-0241

Photographer: M.S. Rezny Photography, Inc.

Printed by the University of Kentucky
Publishing Services, Lexington

Library of Congress Catalog Card Number: 94-61131
ISBN 1-882007-07-7

Cover Illustration: Right: TIFFANY, *Floraform Vase,* glass
(14 1/8 x 4 9/16"), 92 17.137
Left: TIFFANY, *Floraform Vase,* glass
(12 3/16 x 5 1/8"), 92.17.140

A Note On The Entries:

The objects in this catalogue have been selected
from the George and Susan Proskauer Bequest to
the University of Kentucky Art Museum. A
complete listing of all artists represented in the
Proskauer Collection is included in the index.

The abbreviation "b." indicates "born.". Alternative
titles are listed in parentheses. Foreign language
titles are followed by an English translation, in
parentheses, when appropriate. Dimensions in
inches are listed in the order of height, width and
depth; a single measurement denotes height.

A Spectacular Vision:

The George

and Susan

Proskauer

Collection

With essays and entries
by William T. Henning
and Eason Eige

Introduction by
Harriet W. Fowler

University of Kentucky Art Museum

Lexington, Kentucky, 1994

CONTENTS

ACKNOWLEDGMENTS

The University of Kentucky Art Museum deeply appreciates the efforts of many individuals who helped make this project possible. Former directors Priscilla Colt and William J. Hennessey were instrumental in laying the groundwork for the Proskauer bequest's coming to the museum, as was Warren Rosenthal. Robert S. Miller and his assistant, Jo Lynn Berry, graciously expedited a myriad of details regarding the estate settlement; they deserve special thanks. The museum advisory committee, especially John Gaines, Irma Rosenstein and William Cowden, offered enthusiastic, helpful advice; Lee Eaton kindly shared his recollections of the Proskauers, and the Keeneland Association Library and Diane Viert and Patty Lankford of *The Blood-Horse* assisted with inquiries, as did Bettye Lee Mastin of the *Lexington Herald-Leader*.

In the production of the catalogue, University Art Museum curator William Henning and Eason Eige, senior curator, Huntington (West Virginia) Museum of Art deserve much gratitude for their essays and entries on the collection. Rebecca Simmermacher, museum designer, as always capably designed and oversaw production of this catalogue, while Mary Rezny of Lexington handled its photography needs. Staff members Barbara Lovejoy, Maureen Saxon, Kerry Zack, and Barbara Turk made vital contributions to the catalogue's completion in terms of editing, proofreading, and manuscript preparation. Georgiana Strickland of the University Press of Kentucky, through the courtesy of Kenneth Cherry, kindly reviewed the completed text. And Michael Brechner, museum preparator, helped conceive the exhibition design which in turn influenced the shape of the catalogue.

Special thanks must go also to the University of Kentucky administration, particularly President Charles T. Wethington, Jr., Chancellor Robert E. Hemenway, and Assistant Chancellor James P. Chapman for recognizing the importance of the Proskauer bequest and for providing invaluable assistance and support.

Our deepest debt is to George and Susan Proskauer themselves for their extraordinary generosity in sharing their wonderful works of art with all the people of Kentucky.

Harriet W. Fowler
Director

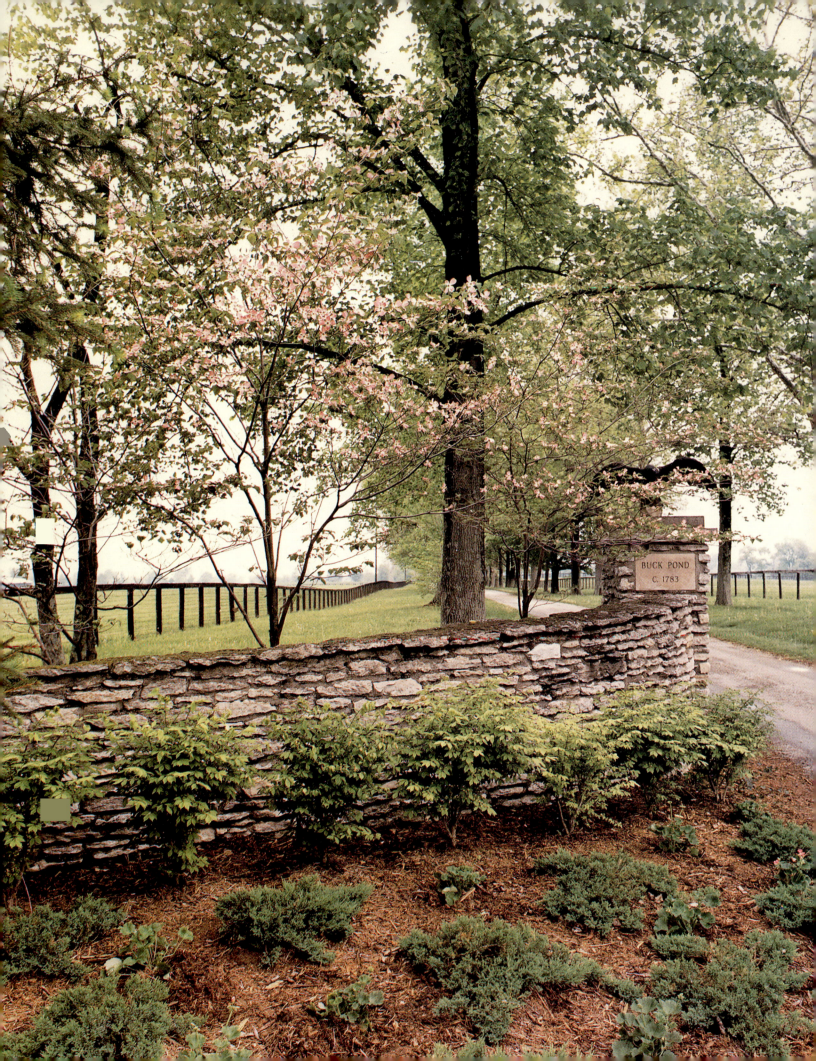

INTRODUCTION

The entrance to 1055 Paynes Mill Pike in Versailles, Kentucky, for nearly twenty years the home of George and Susan Proskauer, is a classic of its kind: massive eagles adorn the gate pillars on which "Buck Pond Farm 1783" is etched in stone, and the driveway sweeps proudly under dogwoods and maples for more than a quarter mile to the main house. Acres of lush pasture, neatly divided by the now-traditional black plank fencing, roll away to either side. For a first-time visitor, the farm's entrance admirably meets one's expectations of a successful central Kentucky Thoroughbred horse breeding operation. In fact, the main residence, a Federal-style home built in 1783-1785 by Colonel Thomas Marshall, a confidant of George Washington and father of Supreme Court Chief Justice John Marshall, is the kind of graceful, traditional architecture one sees throughout the Bluegrass Region.

George and Susan Proskauer with George
Rickey's *Two Lines Oblique*, 1967-69
Buck Pond Farm

Upon arriving at the columned front porch during the Proskauers' residence, however, first-time visitors quickly realized that the owners had interests beyond maintaining a flourishing Thoroughbred farm. The startling, angular presence of George Rickey's *Two Lines Oblique*, a twenty-nine-foot-tall stainless steel sculpture, brooded over the rose garden just outside the front entrance, and a large contemporary metal sculpture constructed of industrial steel guarded the swimming pool off to the right. The main hallway inside yielded an array of surprises for guests. Arshile Gorky's haunting portrait of his sister Vartoosh was jostled by a tonal sculpture by Harry Bertoia, which, George Proskauer noted, "visiting children love to touch." Directly across from the Gorky and Bertoia was Jim Houser's *Mailbox III,* a sleek contemporary oil on canvas in hot electric blue, while a Georg Kolbe bronze rested meditatively nearby. An American primitive eagle weather vane was placed on a long English pine work table beside a Morris Graves pencil drawing of a South American hen and a Picasso drawing of a mother and child. Traditional, modern and contemporary art of an almost dizzying variety announced the Proskauer collection in the front hall alone.

In the formal living room off to the right of the front hall, George and Susan Proskauer had placed some of their greatest treasures. An assemblage by Louise Nevelson—a miniature but no less compelling version of the artist's somber architectural constructions—had a place of honor over the fireplace and was flanked by a magnificent Muller cameo vase, several Tiffany floraform vases, a Daum lamp and Gallé cameo glass objects. Art glass and contemporary sculpture graced table tops, while Tiffany

Opposite: Entrance to Buck Pond Farm, Versailles, Kentucky

lamps, a desk set and Chinese and Japanese artifacts all competed simultaneously for a viewer's attention. A Milton Avery oil *Dune Bushes,* as well as the challenging Dubuffet *Bon Voyage,* the Miró *Personnages, Oiseau* and the Larry Zox *Diamond Drill* surrounded the seating area near the fireplace, with the Calder *The Star* mobile floating overhead. And in the dining room, Jules Pascin's disturbing *Nude (Growing),* next to George Rickey's *Little Sedge,* dominated one end of the room; a Chinese Coromandel lacquer screen next to a particularly outstanding Tiffany floor lamp, was installed at the other end. A five-tiered display case was filled to capacity with stunning art glass objects—Daum, Gallé, Tiffany and Steuben. This was serious, sophisticated art.

Crossing from the formal dining room into the larger informal dining room, one discovered that the Proskauers could change gears in a delightful manner. The sturdy plate rails seemed custom-made for an extensive collection of folk art: intricate nineteenth-century banks and toys, crudely carved cow, roosters—a variety of charming primitive sculpture marched around the architectural space, a perfect complement to the austere simplicity of the spacious room with its large working fireplace. Yet beneath and among all these lively actors, George and Susan Proskauer had placed one of their greatest paintings, Milton Avery's *Green Sea,* no doubt because they wanted to see it as often as possible. Directly across from the Avery and cleverly situated between dining room and kitchen, looking much like a breakfast bar appliance, was a sleek Chuck Prentiss kinetic light box. If one had not sensed the Proskauers' sly wit before, the informal dining room clearly delivered the message.

The library off the dining room yielded more in the way of traditional horse farm memorabilia: trophies, various small equine sculptures and silver julep cups. But competing with these trappings of the Thoroughbred farm owner were the boldly expressionistic Lester Johnson *Two Young Men Facing Left,* Marini's *Blue Horse and Rider* and Karl Schmidt-Rotluff's *Afternoon Sun.* On the second floor landing an Amish quilt and a mid-nineteenth-century Jacquard coverlet draped the stair railing, while upstairs Jean Lucebert's frenzied *Warriors* clamored for attention from the end of the hall. Echoing the imaginative pairings of the downstairs hall, and indeed of the entire house, the separate living spaces at Buck Pond Farm revealed the Proskauers' signatures: each aspect of an installation established a dialogue between or among its participants. Seen together, the modernist works, the art glass and the folk art groupings created an almost spiritual quality, so intensely personal and idiosyncratic were their arrangements.

If Buck Pond Farm's walls held no traditional ante-bellum ancestral portraiture, as so many central Kentucky historic homes do, it was not just the personal taste of George and Susan Proskauer that dictated its absence. The German-born Proskauers came to America with precious little in the way of material histories—both were fortunate to have escaped with their lives. Gotthold George Proskauer (born Gotthold—he added "George" when he came to the U.S.) was born in 1909 near Beuthen in Upper Silesia (now part of Poland), the elder of a paper goods wholesaler's two sons. He wanted to be a psychiatrist and studied at Berlin and Breslau, earning his way through school in part by playing piano in a jazz band. There he first met Susan, who sang with the group. When the Nazis came to power, George was not allowed to study at a university hospital because he was Jewish and trained instead at a Jewish hospital. No psychiatric training was available there, so he pursued his second interest, pathology. His professional skills were of use to the Nazis, and he was not sent to a concentration camp (unlike his parents who died in the camps). George Proskauer worked at the Jewish Hospital in Berlin during the early years of the war. Sent to Lisbon for a seminar in 1941, just weeks before Pearl Harbor, the young pathologist escaped to the United States on a converted Spanish freighter, the only passage he could get. One newspaper account relates the horror of that voyage: the boat, built to hold only a dozen passengers with its cargo, took seven hundred people on board for the journey. Conditions were so appalling that seven died of typhoid fever en route. George Proskauer worked desperately to help the sick passengers.[1]

Berlin, 1937
(George Proskauer third from the right)

Passport for Gotthold Israel Proskauer,
issue date 1941

Susan Proskauer (née Sternberg) was born in 1918 in Breslau. Her schooling ended in the eighth grade, she said, because of Hitler. As a young teenager, besides singing in George's band, Susan apprenticed to a dressmaker and learned the skills that would serve her future career in New York as a fashion designer. As the Nazis' campaign against the Jews intensified during the 1930s, Susan's parents grew increasingly concerned for her safety. Susan noted: "They wanted to get me a visa to the U.S., but it was impossible. It was impossible to...oh, everything was impossible in Germany then." She continued, "So, on Easter Sunday in 1938 my father took me to a nearby slope, kissed me goodbye and I skied for eight hours until I reached Czechoslovakia."[2] She never saw her parents again—both died in concentration camps.

Eventually making her way to New York, Susan worked as a maid in New York City and learned to speak English by going to the movies every day. Hired as a dress designer, she used the training she had received in Germany to become successful, working both independently and for other designers in New York and California under the name Susan Garber. According to several newspaper accounts, a chance conversation with her doctor brought up the name George Proskauer, who Susan discovered was working in New York City at the New York University School of Medicine

Susan Proskauer
(undated photograph)

and Bellevue Hospital. After resuming their youthful friendship, the two were married in 1945, a year after George joined the staff at St. Thomas's Hospital in Akron, Ohio. He remained there as chief pathologist until his retirement in 1977. Susan relocated her clothing business to Akron, where she continued working as Susan Garber. Her couture-inspired fashions of the mid- to late 1940s show the narrow waist and definitive tailoring of contemporary styles as well as an elegance and use of superb fabrics that were her trademarks.

Designer's Week, The May Company
Cleveland, Ohio, September 15, 1946

In the early 1950s Susan saw her first horse race at Ascot Park outside Cleveland. Initially unenthusiastic, she soon found herself deeply interested in Thoroughbreds and noted, "When I get interested in something I have to get involved. So I decided first to find out the horses' bloodlines."[3] She studied Thoroughbred pedigrees carefully and sought professional advice. After the cautious purchase of a $1,900 yearling at Saratoga (which she named, appropriately, Pins and Needles), Susan bought a more expensive mare whose first foal sold well. The horse business had enthralled her.

During the Akron years and in between Susan's travels to Florida, California and Kentucky on horse business, the Proskauers pursued their lifelong interest in art. They had, after all, frequently met for dates at German museums during their teenage years and had spent hours studying exhibitions. Contemporary art excited them—in fact, George worked in watercolor throughout his life, recording Breslau landscapes with a simplicity and underlying geometry that anticipated the couple's early interest in Milton Avery's work. He also created likenesses of the young Susan. That these sketches survived his escape from Nazi Germany seems miraculous.

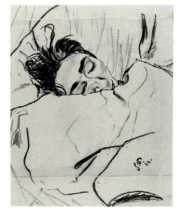

GEORGE PROSKAUER, *Susan Sleeping*,
1932, charcoal on gray wove paper,
(10 1/4 x 13 7/8")

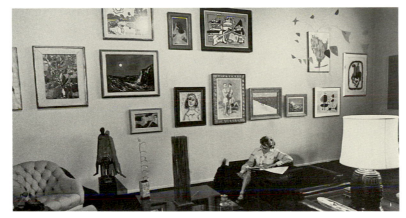

Susan Proskauer at home in Akron, Ohio, 1971

By the mid-1960s the Proskauers had already acquired the bulk of their modern and contemporary painting and sculpture collection and had built a home in Akron with this large collection in mind. Located in a heavily wooded twelve-acre setting overlooking a lake, the contemporary brick and redwood structure featured an eighteen-foot-high living room; its main wall held Avery's *Green Sea,* the two Mirós, and Gorky, Hofer, Marini, Schmidt-Rotluff and numerous other paintings from the collection. Installed just in front of this salon-style hanging were the Calder and Bertoia sculptures and the Koenig *Asinello.* The Kolbe was placed on a pedestal in front of a sweeping glass window; the woods and Susan's Japanese-inspired garden lay beyond. A subdued, monochromatic color scheme (or, as the Proskauers put it, "no color") throughout the house reinforced the sense of the collection's importance. Everywhere the eye rested, an object of interest or delight greeted it. The gallery-like interior did not yet reveal the importance of the Proskauers' art glass nor the presence of the folk art, both of which would be added in earnest during the mid-1970s as the Proskauers planned their move to Kentucky.

Such a move was inevitable given Susan's increasing involvement in the Thoroughbred business. Throughout the 1960s she had been boarding mares with some of the leading farms in central Kentucky, and in 1971 Susan was the leading consigner at the Keeneland summer select yearling sale. Looking ahead to George's retirement, the Proskauers in 1973 bought half-interest in Buck Pond Farm and began renovation of the property, retaining the nearly two-centuries-old farm name. They acquired full interest in the farm in 1977 and moved from Akron. Their Thoroughbred operation, while modest compared to some of the large, well known industry leaders, maintained an emphasis on quality. Constantly upgrading their stock, the Proskauers had some outstanding horses foaled at Buck Pond, including 1980 Eclipse winners Lord Avie and "Horse of the Year" Spectacular Bid, which narrowly missed winning the Triple Crown in 1979.

While the Proskauers demonstrated the business acumen to survive in the Thoroughbred industry, they regarded their horses not just as an investment but as a kind of living art. Susan once commented, "We have a need for art. It's like owning a good horse. It gives you a feeling of satisfaction and beauty."[4] Just as they bought horses they could live with, they acquired art that participated in a very real sense in their daily lives. The highly idiosyncratic nature of the Proskauer Collection is the result of George's and Susan's active engagement with the object, be it a

Tiffany lamp, a droll yard sculpture, or a modernist masterpiece. And it seems noteworthy that nearly all of the works in the collection, whatever their medium, style or culture, are characterized by a sharp contour or line. The graphic, clean edge of an American primitive weather vane or the charmingly irregular shaping of a carved ox, the virtuoso definition of Picasso's *Mother and Child,* the crisply stacked Nevelson arrangement, the floating Calder *Star,* the serpentine neck of a Tiffany lamp, the anxious, angular doodlings of the Dubuffet *Bon Voyage,* even the exquisitely-hued art glass—all reveal a conceptual linearity. That line—nervous, resolute, elegant, self-assured or untutored—attracted the Proskauers' collecting eye and engaged their empathy.

Both George and Susan maintained that vital empathizing, linking process throughout their later years. Chronically ill the last decade of her life and frequently in severe pain, Susan avidly watched visitors react to the art in their home. She never lost that passionate interest in the connection process. "And what do you think of that?" she would inquire as a visitor's eyes turned from one work to another. And in his final days, George Proskauer had that same fervor of interest, reevaluating from a hospital bed those early German watercolors he had painted so long ago, noting with quiet satisfaction that the Breslau landscapes were the beginning of a longing and that they now fit, with grace and logic, into a lifetime of art.

Future owners of Buck Pond Farm may once again install Jouett, Bush or Frazer portraits of their ancestors within the main house or proudly display large contemporary likenesses of their champion Thoroughbred stallions. Pachysandra, iris and hostas will blanket the worn indentations of old sculpture pads, and the rose garden plantings will soon twist and weave with no memory of the towering George Rickey that once stood in their midst. The house and property will reflect the identity of new owners and will reveal their tastes, their possessions. But for a brief period in Buck Pond Farm's long history, two individuals brought a shared vision to that venerable residence, integrating their eager, diverse interests in art with the architectural and landscape spaces. That vision stunned, challenged and delighted everyone fortunate enough to visit Buck Pond Farm during the Proskauer years.

Harriet W. Fowler

1. Lloyd Soyer, "Biography in Brief," *Akron Beacon Journal,* Dec. 22, 1957.
2. Larry Bloom, "Susan, the Matchmaker," *Beacon Magazine, Akron Beacon,* July 18, 1971, p. 11.
3. Ibid, p. 13.
4. "Art for Money," *Lexington Herald,* Sept. 25, 1979, p. C1.

Uncited direct quotations in this essay are from the author's conversations with George and Susan Proskauer. Another useful publication is Cherie Suchy's article, "Following the Path of History," *Thoroughbred Record,* July 8, 1981.

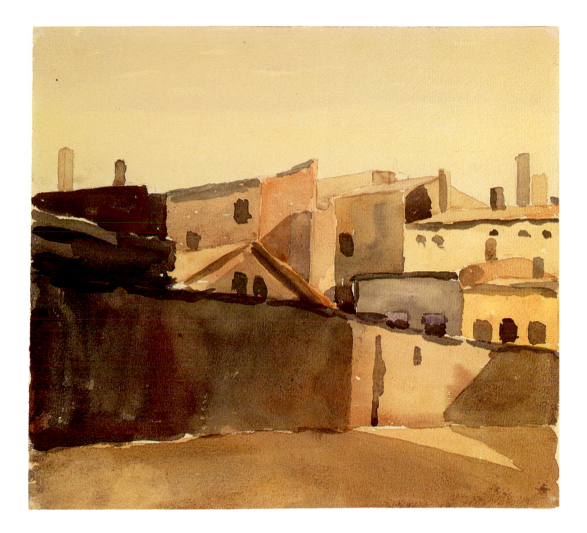

GEORGE PROSKAUER, *Coal Country, Upper Silesia*, 1930,
watercolor on cream wove paper (9 5/8 x 10 5/8")

SELECTIONS FROM THE PROSKAUER COLLECTION

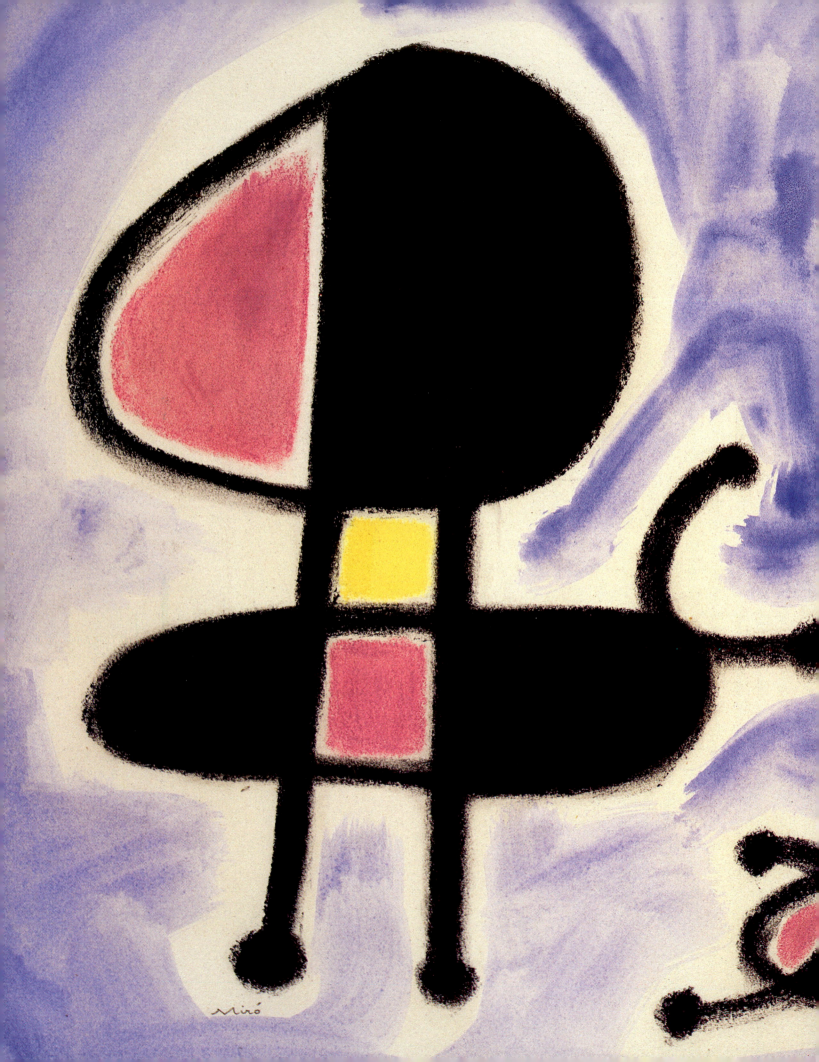

PAINTINGS AND WORKS ON PAPER

The Proskauers' collection of paintings, drawings and prints shows their awareness of and keen eye for significant progressive trends in twentieth-century European and American art, especially the periods just before and just after World War II. Obviously they appreciated various forms of expressionism; they acquired works by important expressionist masters, including Americans Milton Avery, John Marin and Lester Johnson. But there is another and equally significant common link for much that they collected.

Many of the artists, like the Proskauers themselves, suffered and triumphed over political persecution and oppressive treatment by government regimes, or over displacement in the course of war. Europeans Karl Hofer, Julius Bissier, and Karl Schmidt-Rotluff, for example, were censured by the culturally conservative and nationalistic Nazis and were actually forbidden to produce any kind of creative work (thankfully, they did so in secret). In the immediate postwar period, Bernard Buffet, Jean Dubuffet, Marino Marini and Lucebert expressed a social consciousness of the despairing conditions in Europe and the state to which, in their view, the war had debased civilization.

The Proskauers must also have taken great satisfaction in acquiring unique works by two of the most influential and eminently collectible artists of the twentieth century, Joan Miró and Pablo Picasso. At the same time, they showed their adventurous interest in the post-abstract expressionist 1960s, acquiring a Larry Zox hard-edge minimalist painting and a stark super-realist oil by Jim Houser.

Opposite: JOAN MIRÓ (Spanish, 1893-1983), *Personnages, Oiseau* (detail), 1942, pastel and watercolor on cream wove paper (20 3/8 x 26 1/4"), 92.17.34 (see p. 39)

MILTON AVERY
American, 1893-1965

The Proskauer bequest to the museum includes four Milton Avery paintings, two of which are illustrated. Avery biographer Barbara Haskell suggests that *Firs and Pale Field* may have been painted near Gloucester, Massachusetts, where the artist summered in 1943.[1] Avery recorded the landscape with a rapid, almost electric, watercolor brushwork that suggests not only the physical appearance of the place but also qualities of space, atmosphere and mood.

Green Sea, a 1958 oil, was probably painted at Provincetown, Massachusetts, again by Haskell's accounting.[2] It shows the progression of Avery's style to a greater state of simplification and abstraction. Details have been minimized, the composition reduced to large, flat, geometric areas of color. The quickly brushed suggestion of two figures just left of center has the effect of creating a sense of depth.

Both paintings are excellent examples of Avery's best-known work and aptly demonstrate his stated intent: "I try to construct a picture in which shapes, spaces and colors form a set of image relationships independent of any subject matter." Avery eliminates superfluous visual information in his works. The paintings become a kind of poetic distillation.

Avery briefly attended the Connecticut League of Art Students but was otherwise self-taught. Through his own study and observation he became familiar with European and American modern movements, and he was particularly impressed by the fauves and their chief master, Henri Matisse. Avery's painting style seems both a restrained variation on Matisse and a bridge to such contemporary Americans as Arthur Dove and Georgia O'Keeffe.

1. Barbara Haskell, *Milton Avery,* exhibition catalogue (New York: Whitney Museum of American Art, 1982), 189.

2. Ibid., 192.

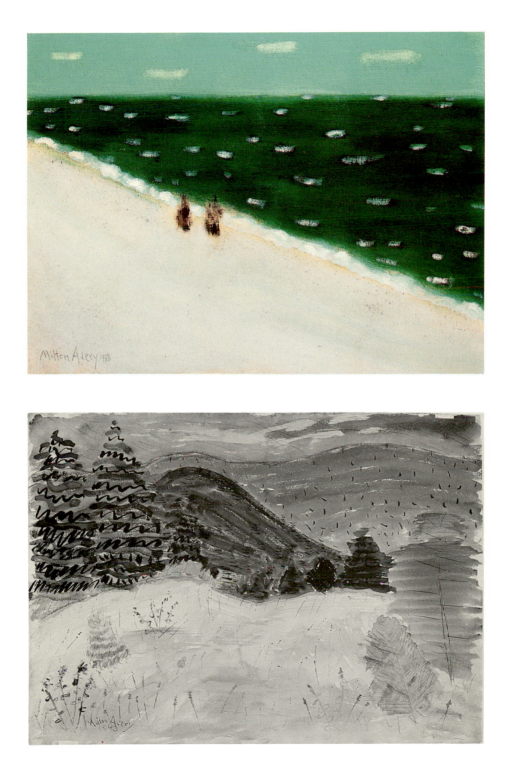

Green Sea, 1958, oil on canvas (18 x 24"), 92.17.4

Firs and Pale Field, 1943, watercolor on off-white wove paper (22 3/4 x 30 7/8"), 92.17.1

LUDWIG BEMELMANS
American, b. Austria, 1898-1962

Writer, illustrator and cartoonist Ludwig Bemelmans was a frequent contributor to *Vogue, Town and Country* and *The New Yorker* magazines. He also painted wall murals for New York's Hapsburg House restaurant, the National Arts Club, the Ritz-Carlton Hotel and the Carlyle Hotel. (At the Carlyle, in fact, the room is still today called the Bemelmans Bar.) But he is undoubtedly best known for more than three dozen books he wrote and illustrated, including the immensely popular six-book series of children's stories telling the adventures of the little French girl Madeline (named after his wife, Madeleine, but minus the second "e" to maintain the distinction). The first in the series, *Madeline*, appeared in 1939. *Madeline's Rescue* won the prestigious Caldecott Medal for children's literature in 1953.

The museum's painting shows Madeline and her friend from next door, Pepito ("son of the Spanish ambassador," who appears in three of the books), surrounded by birds. Their charming expressions and the delightful freshness of the moment are the result of Bemelmans's quick-stroke technique and comic illustrational style.

Bemelmans was born in the Tyrol region of Austria. Growing up he worked as a hotel restaurant busboy, but when he was sixteen he shot a waiter in an argument. The waiter survived; to avoid certain reprisal, Bemelmans's family shipped the youth off to America. On arriving in New York, he immediately found comparable work at the Ritz-Carlton (which years later would be the model for his satiric book *Hotel Splendide* of 1941). Though usually affable, Bemelmans was also at times cantankerous and sardonic. The artist's daughter and only child, Barbara, recalls an example of his acerbic wit and often gruff manner in *Father Dear Father* (1952). Once, when she was five years old, she entered the study while he was working. Bemelmans reportedly blustered, "Get the hell out of here—I'm busy writing a children's book!"

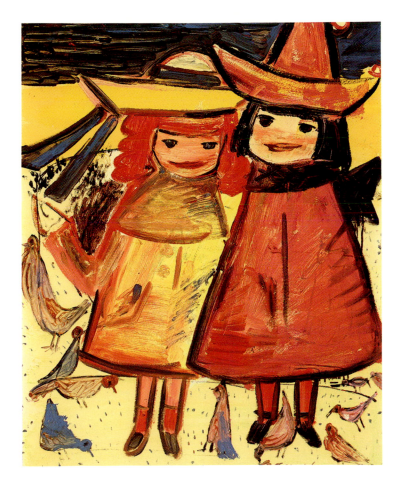

Madeline and Pepito, oil on panel (29 15/16 x 24 1/8"), 92.17.6

JULIUS BISSIER
German, 1893-1965

Julius Bissier's earliest style was representational, and in the 1920s he associated with the German artists' group called *Neue Sachlichkeit* (New Objectivity). Beginning about 1930, however, he became acquainted with persons and ideas that would profoundly sway his thought and dramatically transform his creative work. His friend Ernst Grosse taught him Far Eastern art, culture, and most important, Zen philosophy. He also befriended German abstract artists Willi Baumeister and Oskar Schlemmer. He became aware of Swiss artist Paul Klee's provocative images and in Paris met sculptor Constantin Brancusi, whose spare, streamlined works he greatly admired.

Soon Bissier changed over to an abstract mode that seems an amalgam of these various influences. Like Oriental writing, much about his technique is highly calligraphic. But one sees also delicate tone washes and simple irregular shapes that may remind the viewer of bowls, bottles, jars, vases or geometric figures.

If the images depict anything, Bissier believed, it is the "substance of thought." He described his process as emanating from a meditative state, and he hoped his compositions would induce the viewer's own meditation in response. Only then might one contemplate order, lyricism, rhythmic progression, delicate balance, the personality of colors and other such subjective sensations.

Bissier taught at the University of Freiburg from 1929 to 1939. A major fire at the university in 1934 destroyed a large body of his work. Toward the end of the decade, the Nazi government, pronouncing avant-garde art degenerate and un-German, prohibited him from teaching and painting. He emigrated to Switzerland, where he resided the remainder of his life.

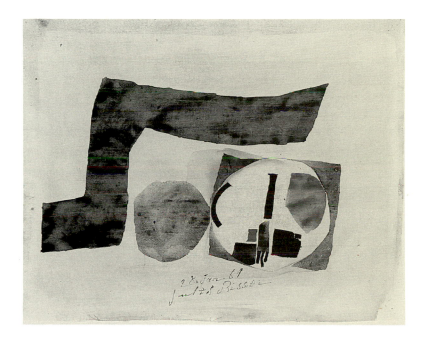

Untitled, 1961, oil and tempera on linen (7 15/16 x 10"), 92.17.8

BERNARD BUFFET
French, b. 1928

From his earliest one-man show at a Paris bookstore in 1947, at age nineteen and while a student at the Ecole des Beaux-Arts, Bernard Buffet has enjoyed steady success and popularity. By age twenty he had participated in both the Salon des Indépendants and the Salon d'Atomne exhibitions, won the Prix de la Jeune Pienture and shared the prestigious Prix de la Critique. Yet, out of step with dominant contemporary fashion, he repudiated nonobjective art, calling it "a return to infancy for tired intellectuals."[1]

Buffet's style is far from photographic realism, however. He uses the brush expressionistically, favoring harsh dark outlines and muted or drab colors. He so distorts the people and objects in his pictures that they appear painfully stretched or gaunt. His works give a sense of impoverishment and isolation, something the French call *misérabilisme*. Indeed, most art critics who favor Buffet's work do so because it speaks pointedly for and to Europe's alienated post-World War II generation.

Limited to depicting just two objects (three, if the drawer is counted separately) on a strangely tilted table, the museum's *Coffee Grinder and Basket* oil painting is typical Buffet. Dark outlines confine dull tans, yellows and blues. The basket and drawer are conspicuously empty, while the grinder sits precariously on the table edge. Brushwork is sure yet agitated. Strong diagonal lines, sharp points and the prominent curve of the grinder handle serve to animate the composition. A sense of uneasiness prevails.

1. Quoted in Claude Marks, *World Artists, 1950-1980* (New York: H. W. Wilson Company, 1984), 120-21.

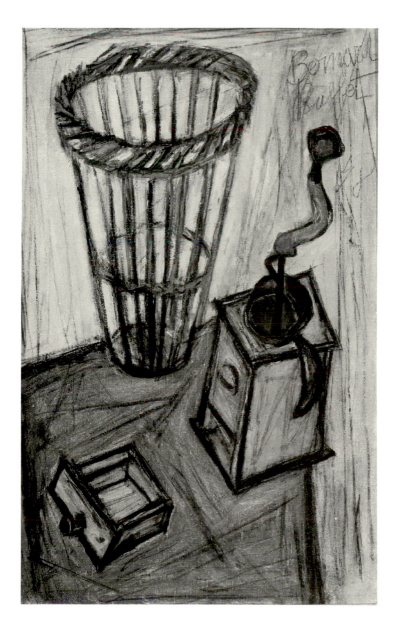

Coffee Grinder and Basket, 1958, oil on canvas (22 x 14 3/16"), 92.17.9

JEAN DUBUFFET
French, 1901-1985

Taking account of two world wars and the substantial suffering they caused, Jean Dubuffet was one of a number of European artists in the 1940s who saw modern civilization as having come to miserable failure. In his view, Western culture, although technologically advanced, was socially and spiritually depraved.

Like the Dada artists twenty-five years earlier, Dubuffet advocated an art characterized by spontaneity and experimentation, uninhibited by premeditated design or intellectualizing. For imagination and fundamental honesty he was inspired by the art of young children and the mentally unbalanced. Better the art should be crude and made of nontraditional materials including trash and debris. If the end product should seem primitive, aggressive, antisocial or grotesque—better still. Dubuffet called his form of expression *art brut,* which translates as "raw art."

For the 1955 *Bon Voyage,* however, Dubuffet used conventional oil paints. A foreboding thicket is separated into left and right zones by a broad street on which two naively-drawn automobiles, droll outline figures await their drivers. The nose of the top car nearly breaks through the horizon line to a long, unencumbered horizontal space above. *Bon Voyage* may suggest a symbolic flight from the tension and ugliness of an inner city.

About 1962 Dubuffet began to produce works in a new style that he called the *hourloupe* series, an improvised term that in French alludes to knobs and gnarls. An outgrowth of compulsive doodling, according to the artist, the work is characterized by uniform meandering outlines that enclose and tie together amoeba-like abstract shapes. These in turn are often filled in with short parallel lines. Typically the subjects pictured are figures or mundane things from everyday life, such as *La Chope (The Beer Mug)* of 1966.

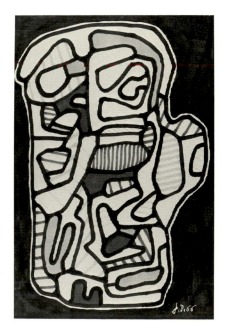

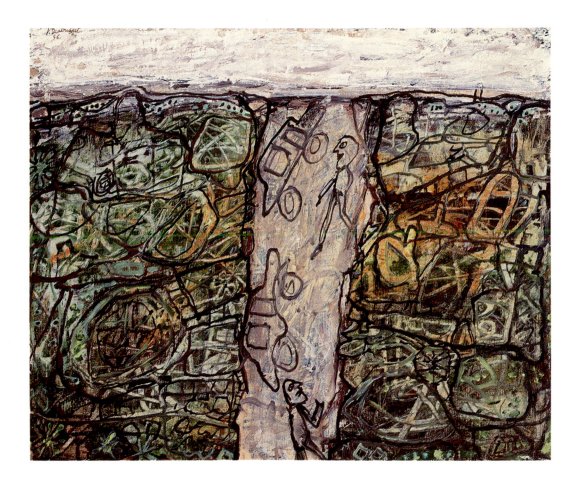

Above: *Bon Voyage,* 1955, oil on canvas (23 3/4 x 28 3/4"), 92.17.14

Opposite: *La Chope (The Beer Mug),* 1966, felt marker
on off-white wove paper (9 13/16 x 6 1/2"), 92.17.15

21

ARSHILE GORKY
American, b. Armenia, 1905-1948

Arshile Gorky's 1936 painting *Woman with Necklace* is a likeness of his younger sister Vartoosh. In 1920, amid both Turkish and Soviet persecution of Armenians and shortly after their mother had died of starvation, the two—alone at ages fourteen and thirteen—fled Armenia to join their father and two older sisters who had gone ahead to the United States in 1918.

When he arrived in America the young artist had not yet begun using the name Arshile Gorky. He was born Vosdanig Manoog Adoian. About 1925, while attending New York's National Academy of Design, he assumed the new identity, by some accounts because he admired the great Russian author Maxim Gorky, by others because Gorky translates as "the bitter one." In either case, it brought him notoriety and social entrée, especially as he would from time to time misrepresent himself as the writer's cousin.

Gorky is best known for his biomorphic, abstract-expressionist paintings of the late 1930s and 1940s. As numerous art historians have noted, his mature work seems to bridge the earlier cubist and surrealist styles of such artists as Juan Gris, Joan Miró and André Masson with the purely semi-abstract and nonobjective approaches of Stuart Davis and Willem deKooning (both of whom, incidentally, were his friends).

Gorky's few portraits, on the other hand, show more the influence of Picasso or the German expressionists. *Woman with Necklace,* one of his last portraits, is painted with a heavy, agitated brushwork that relates tension to both sitter and viewer. Vartoosh's dark eyes, the focal point of the composition, suggest a melancholy and distracted character.

In ill health, partially disabled, disheartened by a 1946 studio fire that had destroyed twenty-seven paintings, and despondent over a failing marriage, Gorky took his own life in July 1948. He was just forty-four years old.

Woman with Necklace (Studio version), 1936, oil on canvas (20 x 16 1/8"), 92.17.18

MORRIS GRAVES
American, b. 1910

Poetic, eccentric, otherworldly, ethereal, mystical, intimate, delicate, Oriental—these are some of the terms critics have used to describe the work of American artist Morris Graves. While a young adult, Graves traveled three times as a seaman with the American Mail Line from his Seattle home port to the Far East. What would become a lifelong interest in the Orient and its cultures, religions, philosophies and arts was probably kindled then. These feelings were strengthened when he later met fellow Northwest-coast artist Mark Tobey (with whom he studied briefly) and the avant-garde American composer John Cage. Both were similarly fascinated with East Asian culture.

Like Tobey and Cage, Graves studied and practiced Zen Buddhist meditation so as to, in his words, "still the surface of the mind and let the inner surface bloom." Soon he converted as well from conventional Western-style, thickly-applied oil painting on canvas to a technique similar to Oriental scroll painting on thin paper, using tempera, gouache, watercolor, ink and even wax, while favoring somber colors. Graves does not imitate Asian subject matter and brushwork, however. His images, consequently, retain qualities of Western-style surrealism.

Over the succeeding years a lone bird has been a recurring Graves motif—a metaphor perhaps, as some critics have suggested, for his view of human predicaments or for himself personally. Sometimes the bird seems forlorn, at other times blind, wounded or maddened. In the museum's pencil drawing, *South American Brush Hen, Bronx Zoo,* from 1937, the small bird is enveloped by a thick surrounding band that stretches thinner near the point of the beak, as if the imprisoned creature might peck through its confine and escape. Graves leaves the outcome uncertain, however, and the viewer, if empathizing with the bird, shares its plight.

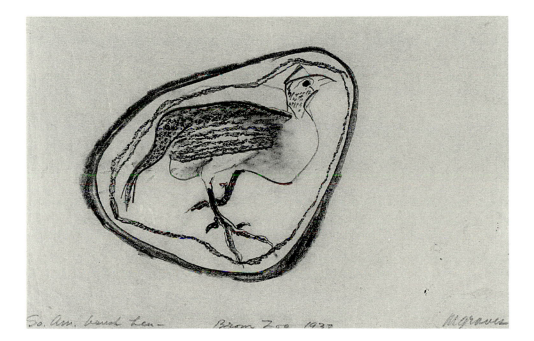

South American Brush Hen, Bronx Zoo, 1937, pencil on buff wove paper (8 7/8 x 11 15/16"), 92.17.19

KARL HOFER
German, 1878-1955

Karl Hofer painted *Three Boys with Ball* in 1943 while his native Germany was in the midst of World War II. In an Allied bombing of Berlin that same year, the artist's studio and more than 150 paintings and drawings were destroyed. He resumed painting at his apartment, but a few months later it too was bombed and many unfinished works were lost.

That Hofer was painting at that specific time in Germany is the more remarkable because, as he recounted in his autobiography published in 1952, he had been ostracized by the Nazi government in the mid-1930s for producing non-Germanic, "degenerate" art and for having been a harsh vocal critic of Adolf Hitler's cultural policy. He was forced to forfeit his professorship at the Berlin Akademie and forbidden to produce art or to exhibit his works, and more than three hundred of his works were confiscated from German museums. "I was not very careful in what I said," Hofer conceded, "and today it appears to me a miracle that I am still alive."[1]

From 1908 to 1913 Hofer lived and studied in Paris, where he developed a particular interest in the work of French postimpressionist master Paul Cézanne. Hofer adapted Cézanne's feeling for geometric form and compositional structure to such paintings as *Three Boys with Ball* that typically feature several abstracted nude or semi-nude subjects. The figures are expressed with sharp, angular outlines, chalky flesh tones and cool colors. As one critic notes, often Hofer's figures appear to hold on to one another, not in romantic embrace but in protective defense. Faces are expressionless and the prevailing mood is stark and melancholy. The works seem an allegory on the plight of a creative spirit in a stagnant and restricting place.

1. Karl Hofer, *Aus Leben und Künst,* 1952, quoted in Joseph Wulf, *Künst im Dritten Reich: Eine Dokumentation* (Berlin and Vienna: Ullstein, 1983), 48.

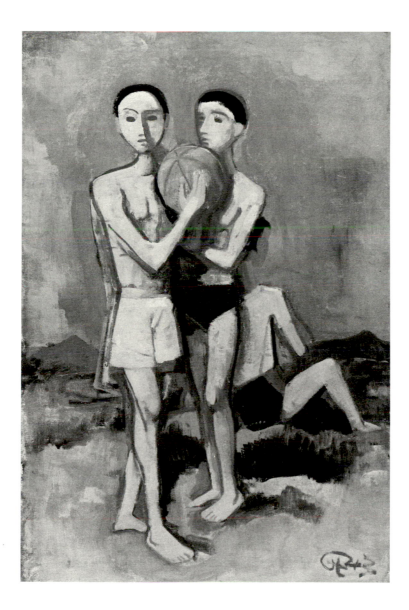

Three Boys with Ball, 1943, oil on canvas (29 3/4 x 20"), 92.17.20

JIM HOUSER
American, b. 1928

In the early 1960s Jim Houser did an about-face stylistically and technically, moving from abstract expressionism to a manner that seems simultaneously to adapt several of the post-painterly trends emerging at the time. His work from that decade and since, of which *Mailbox III* is a fitting example, is in part op, pop, hard-edge and super realism—some of each, but not any one movement exclusively. In fact, the work also looks back to the American precisionists of the 1930s and 1940s, evoking the pared-down, simplified images of Charles Sheeler, Ralston Crawford and Niles Spencer.

Like the precisionists, Houser prefers to show things that are, to begin with, unadorned and streamlined. His studies give no clues to specific period or place but feel solitary and secluded. Favored props include (besides mailboxes) the broad surface planes of clapboard houses and barns, park benches, abandoned boats, lifeguard stands, porch swings and fences. Again like the precisionists, Houser never shows people directly. Instead, the pictured objects become stand-ins for human presence.

The stalwart mailbox in the museum's 1967 oil painting, for example, rises like an American pop icon, heroically looming above the horizon, dramatically lit by cool white daylight, silhouetted against a cloudless blue sky. The signal flag, a singularly conspicuous red diamond shape, is raised to arrest the mail carrier's—and, by extension, the viewer's—attention; the slightly ajar door beckons to be opened. Houser's composition is essentially a tight arrangement of geometric shapes and planes. Brevity and a smooth, exacting paint finish reinforce the stark effect.

A Florida native, Houser earned a B.S. degree at Florida Southern College and an M.F.A. at the University of Florida. He taught painting at Kentucky Wesleyan College in Owensboro from 1954 to 1960 before returning to his home state to teach at Palm Beach Junior College.

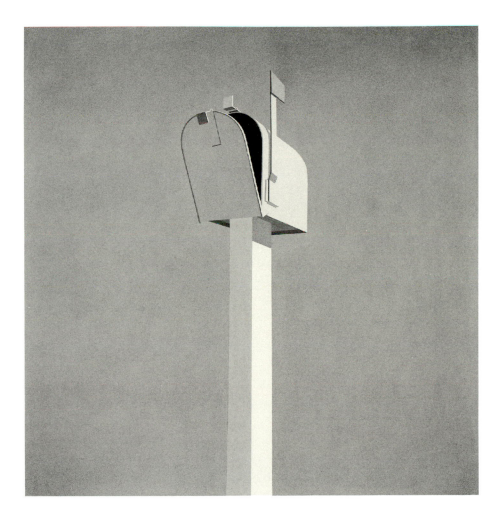

Mailbox III, 1967, oil on canvas (49 3/4 x 48 5/8"), 92.17.22

LESTER JOHNSON
American, b. 1919

Fresh from recent studies at the School of the Art Institute of Chicago, Minneapolis native Lester Johnson moved in 1947 to New York City and there found the only affordable studio space in the Lower East Side's seedy Bowery district. He began to observe and meet the neighborhood's poor, especially the hundreds of derelict men who came to the Christian Herald relief mission across the street from his studio. As he quickly learned, not all the men were old or even middle-aged, not all were unskilled, not all were inarticulate or uneducated, and not all were resigned to their situations.

Johnson had been working in a decidedly abstract-expressionist manner similar to that of Franz Kline. Then, as Lawrence Campbell describes the artist's transformation, gradually his gestural brush strokes began to tighten, to turn in, to suggest ovals more and more resembling gigantic heads. Inspired by the Bowery unfortunates, Johnson began a series of unidealized head or head and upper torso studies to represent the modern Everyman. His stated goal was to give the people dignity. "I wanted to prove that man is more than a man," he declared. "The human and the monumental are contradictory, but I wanted to put them together."[1]

Johnson's typical Bowery paintings are bleak, heavily painted in black, dark grey or dark blue against a neutral background. Usually the pose is squarely frontal or squarely profile, like depersonalizing (and curiously *un*dignifying) police-arrest mug shots. Often the heads or bodies overfill the space, implying perhaps both rigid confinement and the urge to break out. In some paintings, including the museum's *Two Young Men Facing Left,* two or more characters tightly overlap while remaining oblivious to each other, suggesting what one critic calls "crowded aloneness."

Johnson kept the Bowery studio till 1964, when he accepted a faculty position at Yale University, but he continued the "head" series several years longer. About 1970 he began to brighten his palette and created a series that, while still expressing crowded and lonely humanity, shows ranks of urban "pop" figures—stylish businessmen and women or contemporary youths in tee shirts and jeans—all imperviously jostling one another as if on a narrow sidewalk.

1. *Time* 87, no. 7 (Feb. 18, 1966): 74.

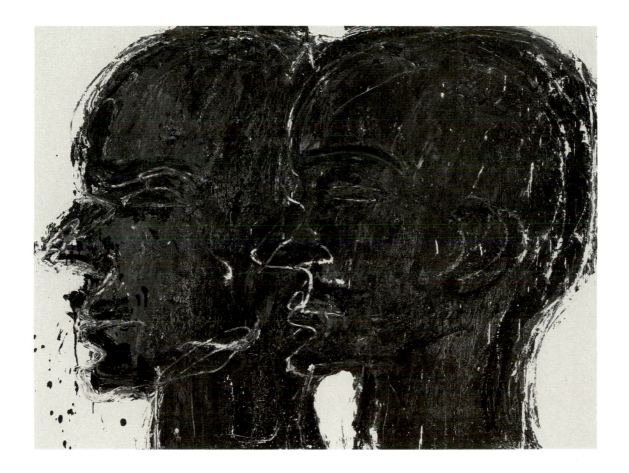

Two Young Men Facing Left, 1964, oil on canvas (30 x 40 1/8"), 92.17.23

31

JEAN LUCEBERT
Dutch, b. 1924

About 1948 Dutch artist Lucebert (who is perhaps as well known for poetry as for painting) affiliated with a group of northern European expressionist artists that called itself *CoBrA,* so named for the home cities of a majority of its members: Copenhagen, Brussels and Amsterdam. Best-known participants included Asger Jorn of Denmark, Pierre Alechinsky and Cornelis Corneille from Belgium, and Karel Appel from Holland. Although most of the group's organized promotion and exhibition activity ended about 1951, the various artists independently continued CoBrA stylistic trends for many years afterwards.

With affinity to art brut—French artists Jean Dubuffet and Jean Fautrier's deliberately coarse expression of Europe's post-World War II Europe's dispirited state—CoBrA reacted against tradition, formality and refinement. Like art brut, CoBrA found validity in prehistoric, primitive and folk art, children's art and the creative efforts of the insane. Additionally like art brut, CoBrA artists usually depict humans and animals, even though obviously distorted.

Lucebert's heavy oil and enamel painting *Warriors* shows that CoBrA artists typically exceed art brut and most other forms of contemporary expressionism in frenzied paint application and ferocious effect. It has been suggested that Lucebert used strongly outlined shapes deliberately to emulate children's art. Grotesque heads, two to the left, one to the right, face off as ready combatants. Their contorted features are crudely brushed, spattered and scored. Seemingly deranged, these menacing characters engage one another in an absurd and violent situation.

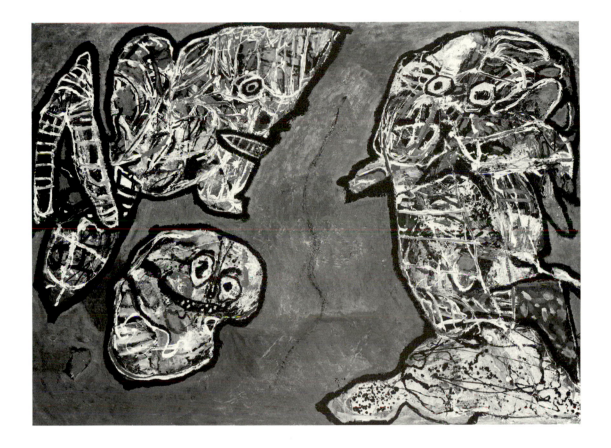

Warriors, oil on canvas (39 1/2 x 55 1/8"), 92.17.25

JOHN MARIN
American, 1870-1953

John Marin delighted in the New England coast. Though he lived most of the year in New York City, he spent many summers in Maine and in 1933 purchased a summer cottage at Cape Split. About half of his total output of nearly three thousand catalogued watercolor paintings are of Maine locales. *Looking Outward,* from 1921, is one of these.

The artist was most interested in capturing the essence of a place, the atmosphere, the light and in particular what he felt was a kind of innate visual dynamism in any given scene. As he saw it, the landscape elements—trees, rocks, grasses, water, even clouds—seem to thrust vigorously one against another. "While these powers are at work pushing, pulling, sideways, downwards, upwards," Marin declared, "I can hear the sound of their strife and there is great music being played."[1]

To achieve his desired effects, Marin developed a personal style based in part on appropriating features of cubism and fauvism. He would deliberately simplify forms to essential shapes. "It's like golf," he said. "The fewer strokes I can take the better the picture."[2] To express both energy and airiness, the watercolor medium well suited his spontaneous brushwork. He rarely painted an image out to the edge of the paper, thereby giving the view a certain buoyancy. Perhaps most distinctively, he devised what David W. Scott calls abstract "lines of force" that seem to convert the picture to a system of transparent overlapping planes. All of these characteristics are evident in *Looking Outward*.

Marin was born in 1870 and reared in Rutherford, New Jersey, across the Hudson River from Manhattan. He studied at the Pennsylvania Academy of the Fine Arts and at the Art Students League. He did not come fully into his own as an artist, however, until after he had studied in Europe between 1905 and 1911, when he was into his forties.

1. Quoted in Sheldon Reich, *John Marin: A Stylistic Analysis and Catalogue Raisonné* (Tucson: University of Arizona Press, 1970), 55.

2. Quoted in Frederick S. Wight, "John Marin—Frontiersman," *John Marin* (Berkeley: University of California Press, 1956), 37.

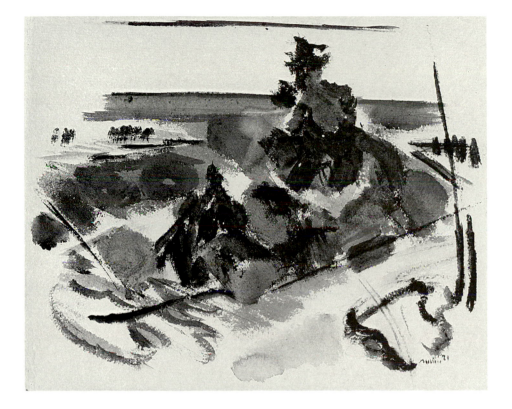

Looking Outward, 1921, watercolor with chalk on cream wove paper (14 x 17"), 92.17.27

35

MARINO MARINI
Italian, 1901-1980

Marino Marini is probably best known as a sculptor of the lone horse and rider theme, an age-old subject he seems to have discovered for himself about 1934-1935. He admitted at that time to being profoundly impressed upon seeing a Chinese Han dynasty tomb horse. Subsequently he took note of equestrian statues in his native Italy and throughout Europe. He admired such powerful Northern Renaissance engravings as Albrecht Dürer's *Great Horse* (1505) and the moving study of the stoic Christian soldier in *Knight, Death and the Devil* (1513). By the late 1930s he became aware of the anguished horse in Pablo Picasso's *Guernica* (1937). After World War II he voiced grave concern for the herds of desperate, ownerless horses he had seen rushing frantically through the valleys of central Italy.

Perhaps fittingly, then, in most Marini sculptures the subjects take on tragic identities—the horse is planted in place, tense, with head thrust forward or upward; the rider leans back stiffly, arms outstretched in seeming vexation or supplication, stubby knobs for hands. The artist commented about riders "ever more powerless" who have "lost control of the animals and the catastrophes to which they succumb."[1] To Marini the theme was an allegory for suffering and homeless humanity, again in his dire words, "the twilight of mankind."[2]

Marini was also a painter and printmaker, and in many of his more expressionistic two-dimensional works, the still-favored horse and rider are less physically and emotionally pained. One such example, the museum's *Blue Horse and Rider,* shows an abstracted rider and his mount moving at a lively gait. Still, they are encircled by an ominous heavy blue band that (like the similar effect in Morris Graves's *South American Brush Hen, Bronx Zoo,* p. 25) psychologically confines and frustrates.

1. Artist's statement in *Contemporary Artists,* 3rd ed., Colin Naylor, ed. (Chicago: St. James Press, 1989), 795.

2. Quoted in Daniel Wheeler, *Art since Mid-Century, 1945 to the Present* (New York: Vendome Press, 1991), 104.

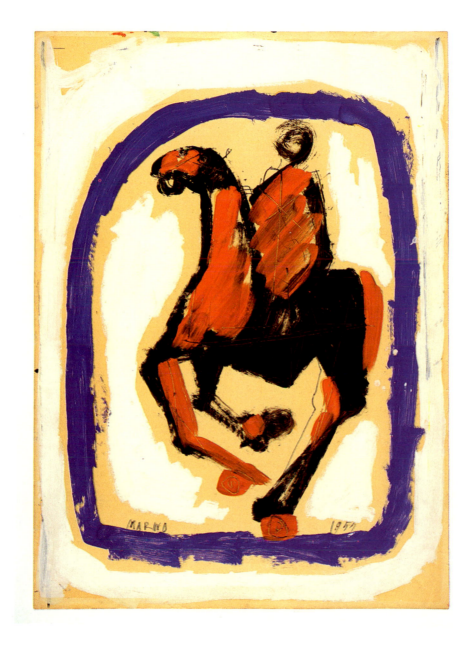

Blue Horse and Rider, 1955, oil and enamel on buff wove paper (33 7/8 x 24 1/2"), 92.17.28

JOAN MIRÓ
Spanish, 1893-1983

Spanish artist Joan Miró, whose drawings, prints and paintings are among the most recognizable modern works of the twentieth century, created a personal type of surrealism. Although many of his images appear to be nonobjective, he insisted they are representational. "For me, a form is never something abstract. It is always a sign of something. It is always a man, a bird, or something else. It is never form for form's sake."

Miró described his invention of signs as extracting "essences" that are latent within conventionally perceived objects. The line, shape or color they assume was a matter of Miró's intuition and free association from the subconscious, as numerous authorities on surrealism and Miró's work have explained. It is a process similar to the *automatism* expounded by surrealist poet and theoretician André Breton, whom the artist met on his eventful first trip to Paris in 1919. In Paris that same year Miró also came to admire the charming primitivism of Henri Rousseau, the biomorphic shapes in Jean Arp's dadaist arrangements and Paul Klee's seemingly naive, childlike compositions. Each of these influences seems apparent in Miró's mature work.

In Miró's ink drawing *Constellations d'une Femme Assise,* whimsical variations on the seated-woman motif are capriciously strewn across the picture surface, assuming the characteristics of one or more astral constellations (though dark on light). Dating from the late 1930s or early 1940s, the drawing is probably related to the twenty-three gouache paintings called the *Constellation* series that the artist began about 1940.

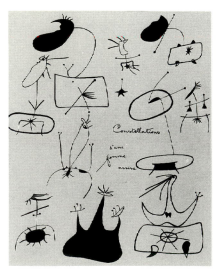

The curious figure at lower right suggests a birdlike creature that will reappear in a separate series of Miró paintings produced in the mid-1940s on the theme of people and birds.

One work from that second group, *Personnages, Oiseau,* of 1942, presents three droll figures; which are the persons and which the bird is uncertain, however. Actually, the conspicuous beaklike faces of the two vertical standing forms suggest hybrid "bird humans," while the horizontal figure might be taken as a bird in flight except for the insubstantial stick wings and strange antenna-like head.

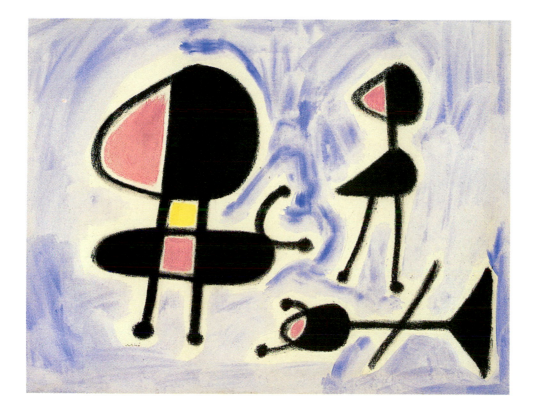

Above: *Personnages, Oiseau,* 1942, pastel and watercolor
on cream wove paper (20 3/8 x 26 1/4"), 92.17.34 (see detail on p. 10)

Opposite: *Constellations d'une Femme Assise,* ca. 1937, ink on cream wove paper (24 7/16 x 19 3/16"), 92.17.35

OTTO MUELLER
German, 1874-1930

As a young man, Otto Mueller apprenticed with a lithographer in his native Silesia. He continued formal study at academies in Munich and Dresden, then remained in Dresden to work within the circle of artists, writers and intellectuals surrounding German dramatist Gerhard Hauptmann (who happened also to be a distant relative). In 1908 Mueller moved to Berlin and soon associated with the expressionist group *Die Brücke,* forming a close friendship with one of its leading members, Ernst Ludwig Kirchner, officially joining in 1911.

Works from Mueller's Berlin years typically show nude youths in a heavily wooded setting. Critics suggest that these represent the artist's feelings at the time about the necessity for harmony between humankind and nature. After serving in the German infantry during World War I, however (and contracting pneumonia for which he was hospitalized and from which he never fully recovered), Mueller's work from the 1920s became more introspective and melancholy. The setting more often moves indoors. *Seated Nude,* probably done in the last year of the artist's life, is an apt example. The figure's angular features and gaunt appearance are typical of German expressionist works, especially those of Kirchner.

After the war Mueller accepted a teaching appointment at the Breslau (now Wroclaw, Poland) academy. Devastated by two failed marriages and in increasingly poor health, he died there in 1930.

Seated Nude, ca. 1930, lithograph on buff wove paper (image: 10 5/8 x 8 1/4";
sheet: 16 3/4 x 13 3/8"), 92.17.36

JULES PASCIN
American and French, b. Bulgaria, 1885-1930

Escaping strife-torn Europe during World War I, Jules Pascin spent only six years of his life (1914-1920) self-exiled in the United States. Still, he can legitimately be considered an American artist, if not for having taken U.S. citizenship, then more explicitly because he produced much of his best painting—including *Nude (Growing)*—during his stay. Moreover, he had considerable influence on several American artists who came to know him and his work: chiefly Alexander Brook, Charles Demuth, Emil Ganso, Bernard Karfiol and Raphael Soyer.

Pascin's favorite subject was the female studio model. He painted an estimated five hundred such subjects in his comparatively short career. Most were jaded young women he had met at brothels and bohemian gathering places. Pascin's friend Ilya Ehrenberg, an expatriate Russian novelist, saw them as more tragic than erotic, commenting that "these short-legged, plump girls with hurt eyes...look like broken dolls."

Pascin had a gift for suggesting three-dimensional form and volume with a thin, wiry outline in which color appears filled in. His choice of palette is usually muted, keeping with the listless mood of his subjects.

The artist was born Julius Pincas in Bulgaria in 1885. He emigrated to Paris when he was twenty and soon after changed his name to the more French-sounding Jules Pascin. There he became interested in postimpressionist, fauve and expressionist painters. In 1912 American artists Arthur B. Davies and Walt Kuhn were in Europe inviting participation in the forthcoming Armory Show. They selected twelve Pascin works. Probably this singular involvement induced Pascin to come to America in 1914 and for the duration of the war. He returned to France in 1920 and, except for a brief visit to New York in 1927-1928, lived the remainder of his life in Paris. Seriously ill, dissatisfied with his recent work and despondent, he committed suicide in 1930. He was forty-five years old.

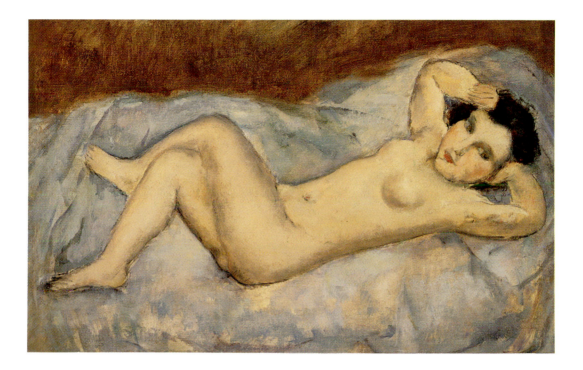

Nude (Growing), 1914-16, oil on canvas (23 5/8 x 36 1/4"), 92.17.38

PABLO PICASSO
Spanish, 1881-1973

Among artists from anywhere in the world, Pablo Picasso must be counted a creative genius, arguably *the* creative genius of the twentieth century. Technically one of the most versatile, he produced paintings, sculptures, collages, ceramics, drawings, lithographs, etchings and aquatints. He was one of the most consistently experimental. It can be confidently stated that he either developed or furthered the way to many of the most important styles of the twentieth century, and in living to age ninety-two, actively making art for more than seventy years, he was one of the most prolific.

Picasso had been delving almost exclusively in the cubist style for a decade when, in early 1917, his friend the French writer Jean Cocteau invited him on an extended trip to Rome, Florence, Naples and Pompeii. The ancient monuments, statuary and artifacts he saw at that time probably inspired what art historians call the artist's "classical" phase. Over the next ten years (though he continued to make cubist and abstract works), Picasso often digressed toward more traditional realism, producing studies of the human figure with emphasis on balance, order, clarity, and sparing use of line and color.

One such classical work is the pencil drawing from 1920 *Mère et Enfant (Mother and Child)*. Bold, strong line sets off the two figures, who are substantial without being massive. As nudes, they suggest an intriguing combination of classic physical beauty, earthiness, and naiveté—reminiscent of works from the artist's pre-cubist blue and rose periods. A tender relationship is suggested by the size and strength of the grasped hands and by the child's trusting gaze into the face of the adult. Perhaps *Mère et Enfant* and similar drawings reveal Picasso's paternal impulses at the time. He had married his second wife, Russian ballerina Olga Koklova, in 1918. In February 1921, just a year after the drawing was done, his son Paulo was born.

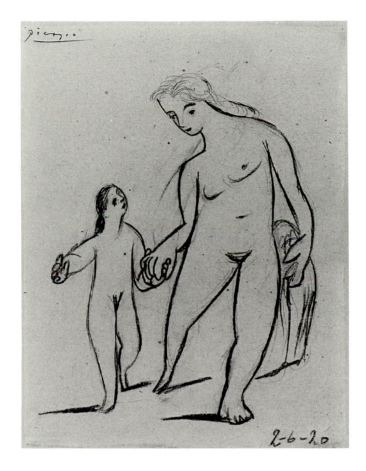

Mère et Enfant (Mother and Child), 1920, pencil on cream wove paper (10 3/4 x 8 3/16"), 92.17.42

EDWARD RUSCHA
American, b. 1937

Advertising-responsive Americans are probably more conditioned to "word" art than any other people in the world. Every day bold words and letters assail one's eyes through signs, billboards, packages, logos and headlines (and one's ears through popular spoken buzzwords, slogans, jingles and clichés). Perhaps motivated by the pervasiveness of commercial design, numerous fine artists have also used words as prominent graphic elements. In the early twentieth century, printed words appeared in the compositions of Georges Braque, Pablo Picasso and other cubists, and in the art of such dadaists as Raoul Hausemann and Kurt Schwitters. In the 1950s and 1960s Larry Rivers, Jasper Johns, and Robert Rauschenberg frequently made words and letters an aspect of their work. Since the 1970s pop artists Andy Warhol and James Rosenquist and super realist Robert Cottingham have featured words or parts of words. For conceptual artists Sol LeWitt and Lawrence Weiner, some compositions are entirely word messages.

Edward Ruscha (pronounced roo-SHAY), who might be called a "pop-conceptual" artist, taps all of these antecedents, though he insists he is interested only in the abstract appearances and implied soundings of words rather than in dictionary definitions or associated meanings. At his most literal, he has admitted that he wants to give ordinary, mundane words new significances so that they become somehow ironically humorous, enigmatic or mysterious.

The drawing *Foil* from 1971 might be read on several levels (despite the artist's assertions to the contrary). Is it a visual pun? Is the artist referring to metal foil, one of the obvious conventional definitions? The word does in fact appear to be made of foil. Is the foil a foil—a contrast, that is—for the vast, wide and empty surrounding space? Is the viewer foiled—thwarted—in attempting to find deeper significance to the drawing? Has the floating word somehow been foiled by external or unseen factors? It reclines on its back, drained, colorless, tired. Is it a word both physically and figuratively in limbo? Ruscha would probably allow that all of these interpretations, and possibly many more, are relevant.

Foil, 1971, pencil, gunpowder and pastel on cream wove paper (11 9/16 x 27"), 92.17.43

KARL SCHMIDT-ROTTLUFF
German, 1884-1976

Karl Schmidt added Rotluff, the name of his native city, to his surname in 1905 to mark what he believed was an extraordinary new beginning, a rebirth. In that year he and fellow German artists Ernst Ludwig Kirchner, Erich Heckel and Fritz Bleyle formed an association in Dresden called Die Brücke (The Bridge). In fact, Schmidt-Rotluff, who at twenty-one was the youngest of the four, suggested the name. The following year Emil Nolde and Max Pechstein also joined the group.

The "bridge" was to be a way from the old to something truly contemporary and brash in art. Inspired in part by the French expressionist artists Henri Matisse, André Derain and the fauves—but tempered by the darker outlooks of German philosopher Wilhelm Nietzsche and the Austrian writer Franz Kafka—these Germans produced a harsher expressionism characterized by exaggerated color, distorted, even crude, form and aggressive painting technique. The purpose was to communicate emotional intensity and to provoke an emotional response from the viewer. Often the work was concerned with political and social issues of the time.

Die Brücke was relatively short-lived, officially disbanding in 1913. Schmidt-Rotluff had already moved on to Berlin. In 1931 he began teaching at the Prussian Academy. Just two years later, with the Nazis coming to power, he and numerous other German avant-garde artists were officially declared "degenerate." He was required to forfeit his position and forbidden to produce creative work. By 1938 the government had confiscated more than six hundred of his paintings, prints and sculptures.

After World War II Schmidt-Rotluff returned to teaching at the Berlin Academy of Fine Art. His later work continued in an expressionist mode, but usually with mellower and more decorative effect. *Afternoon Sun,* a watercolor from 1959, shows sky, sun, water, trees and other landscape elements as bold simplified shapes. The scene may have been inspired by the lake country near the resort town of Dangast on the North Sea, where the artist often visited and for which he held lifelong affection.

Afternoon Sun, 1959, watercolor on off-white wove paper (19 3/4 x 27 3/16"), 92.17.44

RAPHAEL SOYER
American, 1899-1987

If Raphael Soyer's *Reclining Nude* seems conspicuously to be in the studio-picture style of Jules Pascin's *Nude (Growing)* (see p. 43), the comparison is apt. Soyer freely admitted that the nude segment of his work was influenced by the slightly older expatriate whom he had met and befriended. Years later Soyer recalled that he "tried to give those pictures a slightly Pascinish character, which at that time was considered the height of sophistication."

Although the subject appears to be at rest, Soyer's agile rendering technique and design convey a sense of dynamism. Arranged on an understructure of diagonal lines, the pillow edge and left arm form a bold right angle that is repeated quietly in the upper left background, while the position of the model's thighs parallels the left arm and continues the line of the pillow edge from above the right shoulder. Skillfully the artist unified the elements of his composition.

The painting is undated, but a probable time is suggested by an existing photograph taken in the early 1940s showing the artist drawing a reclining nude woman who resembles the model in this work.

Born in Tombov, Russia, in 1899, Soyer emigrated with his family to the United States in 1912. His twin, Moses, and younger brother Isaac also became artists. Most of his work is identified with the American social realists of the 1930s and 1940s, with favorite topics including urban street scenes, derelicts, clerks and office workers. He also painted portraits of such numerous artist-friends as Arshile Gorky, Marsden Hartley, Jack Levine, David Burliuk, Joseph Stella, Philip Evergood, Reginald Marsh, Milton Avery and Leonard Baskin.

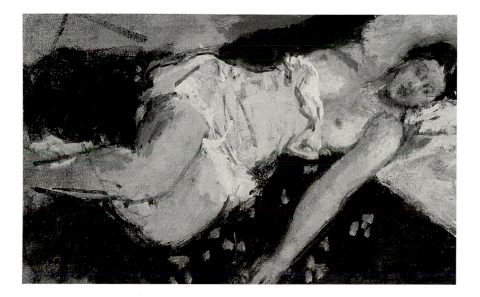

Reclining Nude, oil on canvas (10 1/8 x 16 1/4"), 92.17.47

LARRY ZOX
American, b. 1936

By the time twenty-two-year-old Iowa native Larry Zox arrived in New York City in 1958 to attend the Art Students League (having previously studied at the University of Oklahoma, Drake University and Des Moines Art Center), he was already put off by abstract expressionism, the dominant American art movement of the period. Recent abstract expressionism, he felt, had degenerated mainly into mannered imitations of work by such earlier proponents as Hans Hofmann, Willem deKooning and Franz Kline.

Zox joined numerous other contemporary artists in making a virtual 180-degree turn from abstract expressionism. Refuting the perceived excesses—heavy paint application, gestural and spontaneous brushwork and accidental effects—the reactionary group's paintings featured smooth surfaces, simplified shapes, calculated designs and tight craftsmanship. Critics have called those trends and variations that continued into the 1960s and 1970s minimalism, ABC, post-painterly abstraction, color-field, hard-edge and systemic art.

Critic Lawrence Campbell relates that Zox also became interested in an obvious forerunner of 1960s minimalist abstraction, Dutch artist Piet Mondrian, who, forty years earlier, contended that the surface plane is both the physical and the psychological essence of the work. Mondrian devised an orderly arrangement of rectangular shapes in black, white and primary colors, achieving what he considered "pure" expression and "absolute" painting. Though less doctrinaire, Zox similarly offers a type of pure nonobjective art.

From a larger series of paintings of the same title, the 1967 acrylic *Diamond Drill* is not a pictorial representation but rather an exercise in geometric design. Interpenetrating triangles and diamonds suggest modular cadence and visual tension. The crisp off-white bands (actually the unprimed canvas showing through) against the dark green field establish a sense of equilibrium and correct proportion. Though the stripe pattern is to one side of the central axis, the arrangement seems intuitively balanced by the imposing void on the opposite side.

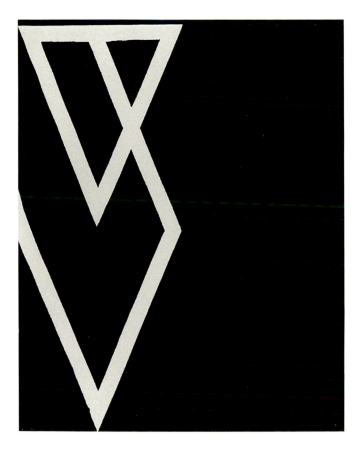

Diamond Drill, 1967, acrylic on canvas (19 1/8 x 16"), 92.17.49

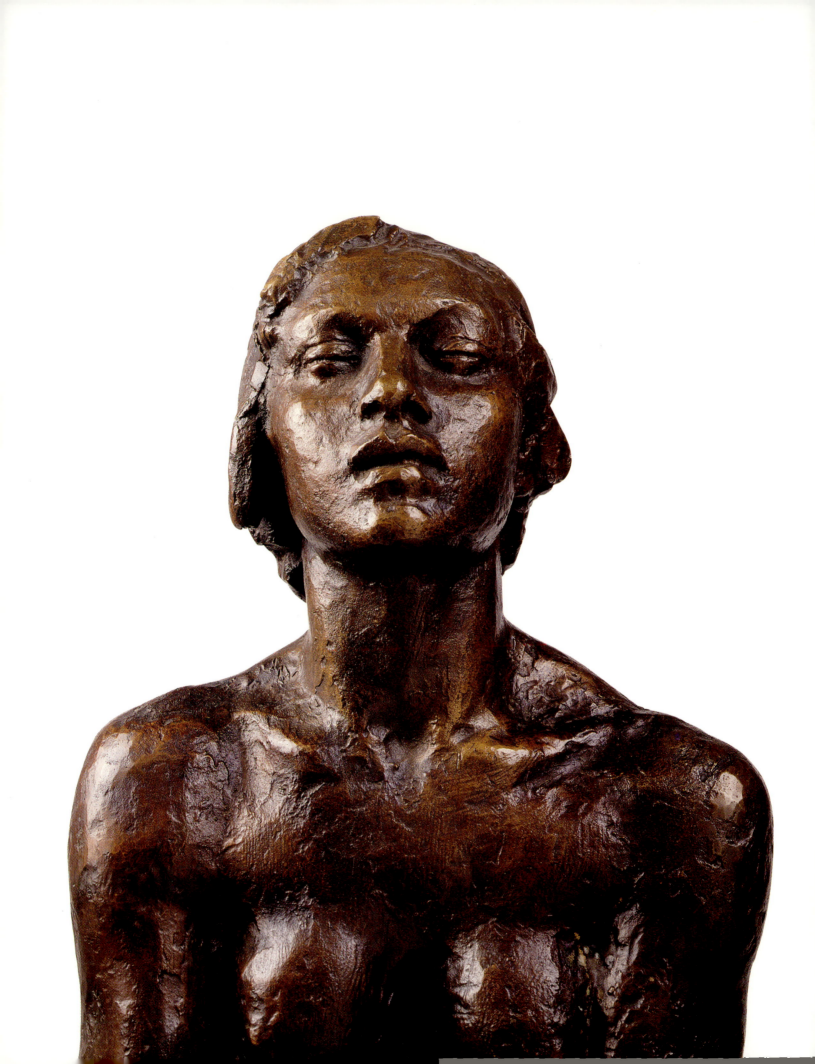

SCULPTURE

Again revealing their understanding and appreciation of contemporary trends, the Proskauers collected a wide range of progressive styles in sculpture: from Georg Kolbe's gritty expressionism to Nina Winkel's lyrical simplification of the human form, David E. Davis's sheer geometric abstraction and Louise Nevelson's subtle abstract compositions made from discarded materials.

Like many of the artists who created the paintings and works on paper in the collection, several of these sculptors either fled Europe for economic, political or artistic freedom or suffered persecution during the course of World War II. Kolbe, for example, endured the troubles in Germany though his work came under negative criticism from Adolf Hitler himself. Winkel managed to flee the country after a year's imprisonment by the Nazis. Davis left the strife of his native Romania in the mid-1930s. Italian-born Harry Bertoia came to America with his family in 1930.

The Proskauers were also fascinated by the aesthetic possibilities of sculptural works designed to incorporate effects of actual motion. The long slender bronze rods of Bertoia's piece not only gently sway when touched or blown by air currents, but, as they glance together in the process, generate astonishingly brilliant sound. Movement is a key design element in the several works by George Rickey and in Alexander Calder's delightful mobile with its continuously shifting arrangement of streamlined abstract shapes.

Opposite: GEORG KOLBE (German, 1877-1947), *Sigende* (detail), 1937 (Cast #3), bronze (23 1/8 x 14 1/8 x 18 1/8"), 92.17.67 (see p. 67)

KENNETH ARMITAGE
British, b. 1916

Kenneth Armitage was born and reared in Leeds, England, and from 1934 to 1937 he attended the Leeds College of Art, a school with notable success in sculpture instruction. Armitage's Yorkshire neighbors Henry Moore and Barbara Hepworth had studied there earlier, and both had considerable influence on the generation of British sculptors that came to prominence immediately after World War II.

If not directly inspired by Moore, Armitage shares his interest in greatly simplified and stylized human forms, usually one or two standing or seated together, often flowing one into the other. Like most Moore works, Armitage's sculptures have a frontal view; they are not necessarily seen well from the sides or back. Many Armitage works from the 1950s, including the museum's *Two Seated Figures* of 1957, like Moore's, show little interest in facial features; heads are often reduced to proportionally small ovals, reminiscent, as numerous critics have noted, of furniture knobs or architectural finials.

No simple Moore imitations, however, Armitage's sculptures also show obvious and significant differences. Unlike Moore's usually monumental and heroic types, Armitage creates smaller, more intimate subjects in casual situations—people standing into the wind (in fact, Armitage wrote an essay in 1951 titled *People in a Wind*) or sprawled on a couch or the floor, sitting, listening, enjoying ordinary low-key pleasures. They seem mildly amusing, perhaps because of the knoblike heads and the spindly arms and legs (which often do not tally with the number of figures suggested) that protrude from an uneven, rectangular, vertical back slab.

Armitage went on to study at London's Slade School of Art from 1937 to 1939, then served five years in the British army, during which time he made aircraft models for recognition drills. From 1946 to 1956 he headed the sculpture department at the Bath Academy in Corsham, then returned to London where he still maintains a home and studio. He has been a visiting tutor at the Royal College of Art since 1974.

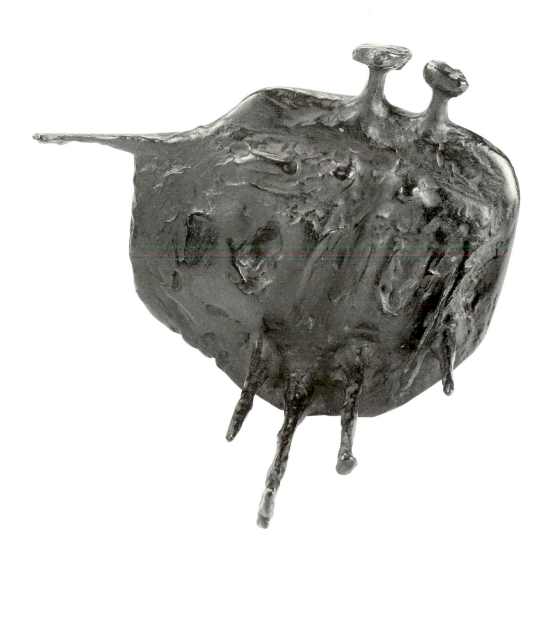

Two Seated Figures (Version A), 1957, bronze (10 15/16 x 14 5/8 x 9 5/8"), 92.17.50

HARRY BERTOIA
American, b. Italy, 1915-1978

The museum's untitled Harry Bertoia sculpture is one of a series of abstract works created in the 1960s and early 1970s that the artist categorized as "tonals," so called because the potential for producing actual sound is an element of their design and construction. Works in the series range in size from pedestal or tabletop (that is, as small as twenty inches in height) to as tall as thirty feet, placed outdoors or in expansive contemporary interiors.

Most tonals are characterized by a system of close, equally spaced and equal-length vertical metal rods that rise from a low rectangular base. When the flexible rods are gently moved, either by hand or by wind, they glance off one another and resonate. When many rods (365 in the museum's piece) touch together, the reverberations compound. The resultant sound can be remarkably loud and quite sonorous.

Some observers see in the tonals a similarity to reeds or tall grasses swaying gently in the wind. To most, however, they embody geometry, machine precision, exactness and orderly repetition—effects particularly compatible with the hard rectangular design aesthetic of International Style architecture, the predominant contemporary mode in Bertoia's time.

Bertoia was born in Italy. His father brought him to the United States when he was fifteen. He is probably as well known for the furniture he designed for Knoll Associates in the 1950s, including the wire-shell, contour-form "Bertoia Chair."

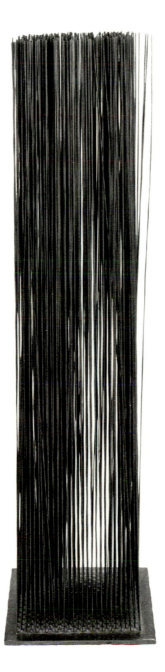

Untitled, 1968, bronze (30 5/8" x 7 15/16 x 8 15/16"), 92.17.54

ALEXANDER CALDER
American, 1898-1976

"Why must art be static?" Alexander Calder demanded in 1932 at the first gallery showing of his newly-invented motion sculptures. Why indeed? As Calder might well have noted, masks, costumes and other wearable art forms take on motion with the wearer's movements. Innumerable toys and decorative art objects down through the centuries have had parts designed to move. Even by the time Calder was a young man, several contemporary European artists (Lazlo Moholy-Nagy, Naum Gabo and Marcel Duchamp, for example) had experimented with motorized "kinetic" works in the spirit of the machine age.

Still, sculpture with components that move is probably more identified with Calder than with any other artist. His "mobiles" (as they were first dubbed by Duchamp) are unique: unique generically as a creative art form and unique specifically as individual works with ever-changing compositions.

Using principles of gravity, weight, balance and counterbalance, Calder suspends an assemblage of flexible wires and thin metal plates—abstract shapes cut to resemble streamlined birds, fish, leaves or flower petals—that gently turn or revolve when propelled by the natural air currents in a room. Consequently the observer must allow time for viewing and enjoyment. The museum's *The Star,* medium-sized among Calder mobiles, is so named because of the small, yellow four-point shape that, by itself, appears miraculously to counterweigh a much larger portion of the total sculpture.

Calder also produced nonmobile sculptures, fittingly called (first by fellow artist Hans Arp) "stabiles," as well as paintings, drawings and prints. His seemingly playful designs may be partially inspired by the work of Spanish surrealist Joan Miró, whom he met in 1927 and with whom he maintained a lifelong friendship.

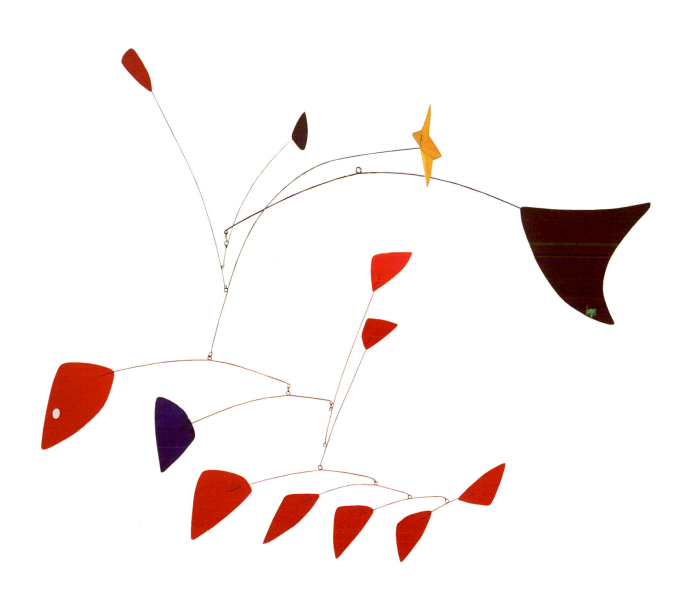

The Star, 1960, polychrome sheet metal and steel wire (35 3/4 x 53 3/4 x 17 5/8"), 92.17.55

DAVID E. DAVIS
American, b. Romania, 1920

Romanian-born David E. Davis emigrated to America as a teenager in 1934. His father, a rabbinical scholar, preceded the family by two years, settling in Middletown, Ohio. Young Davis began studies in painting at the Cleveland Institute of Art in 1939, but, with the intervention of World War II and military service, did not finish his B.F.A. there until 1948. The following year he became a staff artist at Cleveland's American Greeting Card Company, rising to head of his department in 1958 and continuing in that capacity four additional years.

In 1961 Davis was also on his way to completing a master's degree in painting at Case Western Reserve University when he took an elective course in sculpture. The class had a profound effect. Soon afterward he changed emphasis, and he has worked independently as a sculptor since leaving American Greeting in 1962.

About 1972 Davis felt a need to make his creative process more coherent and disciplined. He devised a compositional system of geometric proportional relationships that he called the "harmonic grid." Cleveland Museum of Art curator Edward Henning explains that the system is based on a 1:3 rectangle that is in turn divided into twelve smaller rectangles, then dissected by diagonals to yield additional triangles, trapezoids and parallelograms. Despite the seeming restriction, countless combinations and juxtapositions are possible.[1] In application to sculpture some of the modular divisions become solid form, others become surrounding space. The resulting object suggests a three-dimensional pop-up from the grid plane. The museum's *Interlude* from 1981, in intersecting black and white marble, is a comparatively small and simple demonstration of the premise. Davis has also fashioned large and more complex geometric "totems" up to twenty-five feet high.

Today Davis divides time between homes in suburban Cleveland and Casey Key, Florida. He continues to produce work with geometric shapes in formal abstract designs, although, since the mid-1980s, his style is less dependent on the harmonic grid.

1. Edward Henning, "The Art of David Davis: Freedom within System," *Art International* 22 (Nov.-Dec. 1978): 11-16.

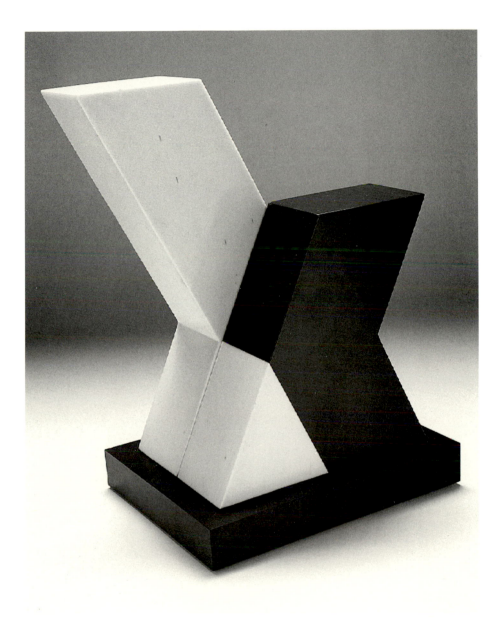

Interlude, 1981, black and white marble (17 3/4 x 13 15/16 x 9 1/4"), 92.17.60

FRITZ KOENIG
German, b. 1924

German sculptor Fritz Koenig titled his 1953 bronze *Asinello* from the Italian word for foal, little ass or little donkey. It is an obvious reference to the absurdly small beast of burden that seems incapable of carrying its rider. The man's figure appears especially weighty in that the torso's massive slab shape admits no light beneath the arms and its length alone is half again the height of the donkey. Furthermore, the rider's feet nearly touch the ground.

Equestrian subjects have a long tradition in the history of art, but *Asinello* does not present a great steed mounted by a mythic hero, monarch, knight or soldier. Instead, a figure riding a donkey recalls religious motifs, particularly Christ's Palm Sunday entry into Jerusalem, a theme of bittersweet and short-lived triumph. Similarly, Koenig's rider, with his impassive facial expression and confined arms, conveys futility and a sense of pathos.

The Italian title may reflect Koenig's extended stay in Italy just a year before the work was completed. Several other equestrian works he produced in the 1950s almost certainly indicate his additional awareness of the prominent Italian contemporary sculptor Marino Marini, whose forte was the horse and rider. Marini also used the theme to express humanity's anxiety and despair, especially in the years immediately following World War II (see p. 37).

Both Koenig and Marini represented a trend in modern sculpture that flourished from the 1930s through the 1950s. Based substantially on earlier pioneering work by Ernst Barlach, Constantin Brancusi and Aristide Maillol, the style is characterized by heavy, simplified, closed-in, compact, often monolithic forms that effectively express archaic strength. From the mid-1960s Koenig's work evolved toward greater abstraction, and after 1970 toward geometric assemblage.

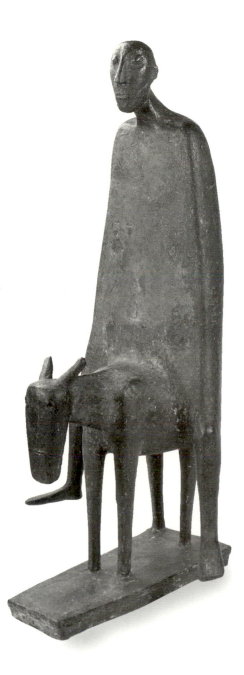

Asinello, 1953, bronze (32 7/8 x 16 5/16 x 15"), 92.17.66

GEORG KOLBE
German, 1877-1947

German sculptor Georg Kolbe enjoyed critical and financial success throughout his long career, including the years of the Nazi regime and World War II. Although Adolf Hitler had wanted Kolbe placed on the government's official list of "un-German" and "degenerate" modern artists, which would virtually have prohibited him from producing art in his native country, the Third Reich's propaganda minister, Joseph Goebbels (whose personal taste in art was more progressive than Hitler's), argued against it. Hitler yielded, and the apolitical Kolbe was allowed to continue working undisturbed.

Neither Aryan nor heroic nor glorifying of state socialism and the ideals of German womanhood, Kolbe's *Sigende* of 1931 is the very type of work that offended Hitler. The crouching figure's pose is tensed; the mood seems troubled. One hand tight-fisted, the other clutching at the earth, eyes nearly closed, mouth open uncertainly as if to moan—the woman's demeanor fails to communicate "appropriate" Teutonic superiority. Moreover, the sculpture's surface lacks refined finish.

What Goebbels must have appreciated was Kolbe's roots in the German expressionism of the years 1910 to 1930, in which works of art were measured by their emotional intensity and their revelation of the artist's personal pain and fear. Kolbe was, in fact, a close friend of expressionist painter Karl Schmidt-Rotluff (see p. 48) and a contemporary of fellow German expressionist sculptors Wilhelm Lehmbruck and Ernst Barlach.

Critics have noted a similarity of Kolbe's expressionist works to French sculptor Auguste Rodin's powerful bronze figures. Such comparison is entirely fitting. Rodin's stylistic influence on European sculpture at the end of the nineteenth and early twentieth century was pervasive. Kolbe met Rodin and visited his Paris studio in 1909. *Sigende* is remarkably similar to the older master's *Crouching Woman* from 1892.

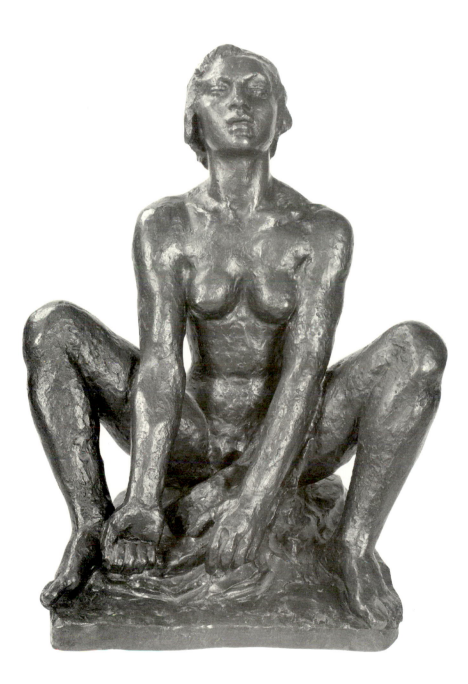

Sigende, 1931 (Cast #3), bronze (23 1/8 x 14 1/8 x 18 1/8"), 92.17.67 (see detail on p. 54)

LOUISE NEVELSON
American, b. Ukraine, 1899-1988

The Proskauers' Louise Nevelson sculpture is a scaled-down version of the stacked-compartment, large wall-like assemblages for which the artist is most famous. Not until Nevelson was in her mid-fifties, however, did she begin experimenting with making artworks from old crates and discarded or "found" materials. She particularly favored wooden architectural elements: balusters, ornamental moldings, finials, railings, chairlegs and other furniture fragments. Frequently she acquired these materials from ruined structures or at actual building demolitions.

After first painting all the potential components a solid color for coherence and unifying effect, she would arrange the various pieces within the open crate boxes, then stack the units to form a kind of screen. Although abstract, the designs are not without subjective meaning. As Nevelson rejuvenated, reordered, and brought new beauty to what Wayne Anderson calls a "disparate array of societal debris," many modern viewers feel nostalgia for those ruined forms.

Occasionally Nevelson worked in white, gold, and even polished metals and clear plexiglas, but she admitted her favorite color was black. She thought it aristocratic and formal, in the same way a black tuxedo, a grand piano or a limousine is formal. She also felt that black imparts spiritual qualities, a sense of fulfillment and completion. Regarding the works in black, she called herself an "architect of shadows."

Nevelson was born Louise Berliawsky in Kiev, Ukraine, in 1899. At age six she emigrated with her family to the United States. She grew up in Rockland, Maine, where her father operated a lumber business (and where she admits having first developed an appreciation for wood scraps). After studying at the Art Students League from 1929 to 1930, and with the eminent abstract painter Hans Hofmann in Munich the following year, she assisted Mexican master Diego Rivera on his mural for the New Workers School in New York. She died at her Manhattan home in 1988.

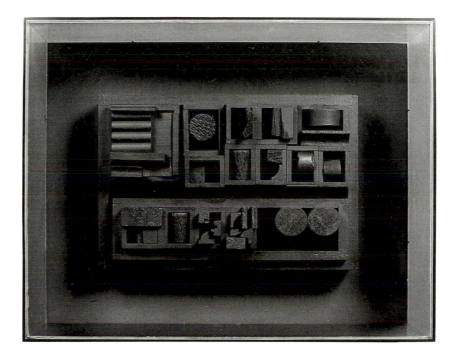

Untitled, polychrome wood and plexiglas (15 3/8 x 19 5/8 x 4 7/8"), 92.17.72

GEORGE RICKEY
American, b. 1907

For George Rickey, the movement of a sculpture is as much an aspect of art as the physical object itself. "The visible motion is the design," he has said.[1] "Movement itself is my medium."[2] Not surprisingly, Rickey has been compared to Alexander Calder (whose mobiles he admires). But whereas Calder's works feature free-form organic shapes and seemingly capricious motion, Rickey's move on orderly prescribed paths and appear mechanical. "My technology is borrowed from crafts and industry," he goes on to explain. "It has more in common with clocks than sculpture."[3]

An apt allusion: Rickey is the grandson of a clockmaker and son of an engineer, and he fondly recalls both as influences. The long tapering metal blades that are a principal feature of most Rickey works, including the museum's *Two Lines Oblique* (see p. 1), are reminiscent of clock hands or gauge pointers. Although designed to move with natural air currents rather than with motors, weights or gears, the blades often inscribe circular arcs, as clock hands do. When several blades rotate at the same time, the crisp action suggests scissoring as they momentarily cross. The general verticality and restricted blade motion of works like *Little Sedge,* on the other hand, remind one more of metronome needles.

Though Rickey was born in the United States, his father's work took the family to Great Britain. Rickey received his formative education in Scotland and completed studies in painting at England's Oxford University. He also studied painting in Paris with André Lhote, Fernand Léger and Amédée Ozenfant. He did not turn to sculpture seriously until he was in his early forties, while attending Chicago's Bauhaus-oriented Institute of Design. There he realized his mechanical inclination and learned the technical processes that led eventually to his distinctive mature style.

1. Quoted in Carter Ratcliff, "George Rickey," *Britannica Encyclopedia of American Art,* 1973, 475.

2. Artist's statement in *Contemporary Artists,* 3rd ed., Colin Naylor, ed. (Chicago: St. James Press, 1989), 795.

3. Ratcliff, 475.

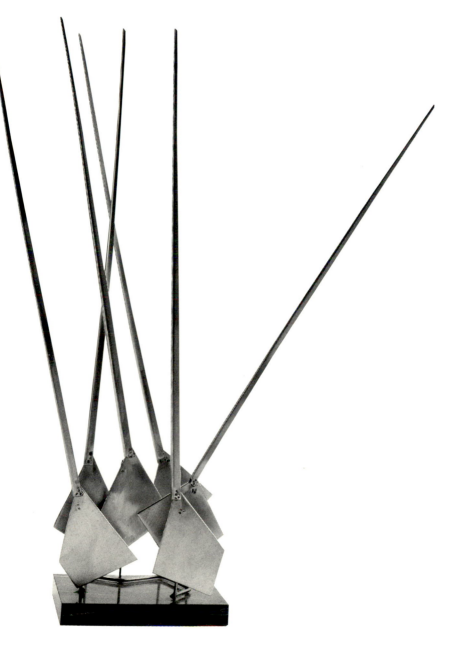

Little Sedge, 1961, stainless steel (21 1/16 x 6 13/16 x 4 1/2"), 92.17.79

HANNAH L. SMALL
American, b. 1908

The Proskauers displayed Hannah L. Small's marble standing figure in the garden off their sunroom. Though not large, the sculpture nicely held its own in the natural setting, its strong monolithic shape at home with the earth, its pinkish stone complemented by surrounding greenery. Indoors, however, the figure is more noticeably a dancer, specifically a ballerina, with feet turned out and crossed one in front of the other in a common ballet rest position.

As an unidentified critic for *Art Digest* first noted in 1943, Small's work represents the "direct carving" (also called in Europe *taille direct*) movement in modern sculpture that was at its height in the 1930s and 1940s.[1] With roots going back to the early twentieth century and the work of French artists Paul Gauguin and Auguste Rodin and the German Ernst Barlach, the movement's chief American proponents were European immigrants Robert Laurent, José deCreeft and the particularly influential William Zorach, who was teaching at the Art Students League in New York at the same time Small studied there. These direct carving advocates further championed the idea of "truth-to-material" and believed that a kind of symbiotic relationship should exist between artist and chosen medium. Consequently, design tends to be compact and to relate to the essential mass of the raw material, as Small's *Pink Dancer* aptly demonstrates, additionally making the work reminiscent of pre-Columbian and other forms of primitive sculpture.

1. *Art News* 42 (Mar. 1, 1943): 23.

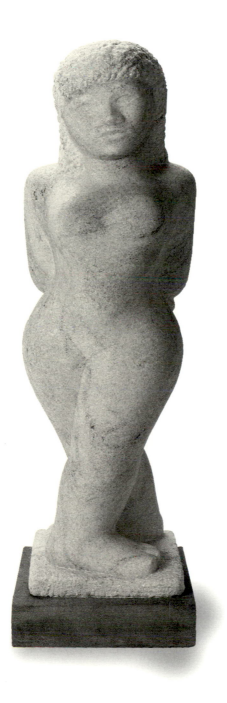

Pink Dancer, pink marble (32 13/16 x 10 3/16 x 10"), 92.17.82

EDGAR TOLSON
American, 1904-1984

Self-taught sculptor and woodcarver Edgar Tolson is one of Kentucky's most popular twentieth-century folk artists, but he did not begin making art in earnest until age fifty-three, when a stroke left him partially paralyzed and unable to work. To speed rehabilitation he whittled, and soon his carvings developed into images of people and animals. A sometime Baptist preacher (feeling the call at age seventeen), Tolson usually made figures that represent persons and stories from the Bible. He considered the accounts of Adam and Eve's disobedience to God among the most portentous, not just of Scripture but of all history, because that first sin caused humanity's fall and unrelenting troubles.

Tolson produced more than one hundred sculptural tableaux based on Adam and Eve themes. The works are all nearly the same size (twelve to fifteen inches high) and are stylistically similar, yet each is subtly different. Moreover, the series offers different progressions in the Genesis narrative: happiness beside the tree of life amid birds and animals, temptation by the serpent (the Proskauers' piece), original sin, expulsion from the garden. One such Adam and Eve was selected for the Whitney Museum's Biennial Exhibition of American Art in 1973.

Typical of the best folk artists, Tolson cared little about correct anatomy, proportions or details. With his pocket knife he fashioned simple, straightforward works that express frankness, honesty, humor and charm.

Tolson was one of nine children born to a farming family in Powell County, Kentucky. He completed six grades of schooling before finding it necessary to work full-time. Over the years his jobs included those of farmer, coal miner, stone mason, cobbler, chairmaker, general carpenter and, as previously noted, occasional preacher. In 1950 Tolson moved to Campton in Wolfe County, where he lived until his death in 1984. A son, Donny, is continuing in his father's woodcarving manner.

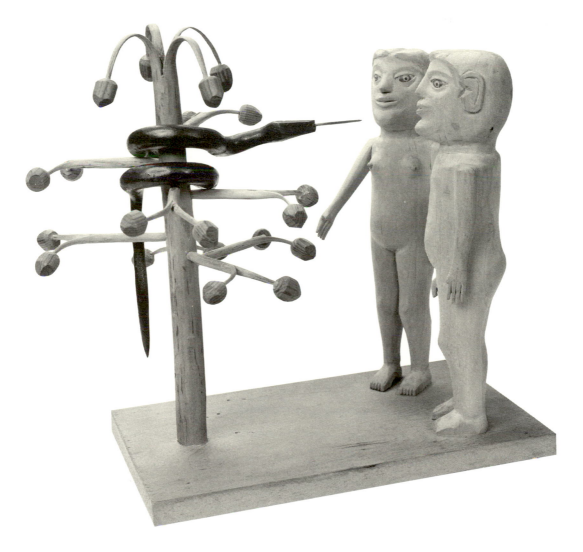

Temptation Scene, 1975, polychrome wood (13 1/2 x 14 3/4 x 8 13/16"), 92.17.84

NINA WINKEL
American, b. Germany, 1905

German-born sculptor Nina Winkel trained at art academies in Essen, Düsseldorf and Frankfurt. By the mid-1930s she was well on her way to establishing a reputation when the Nazis came to power and reversed her progress. In 1942, after spending a year in a concentration camp and seeing her creative work from the preceding decade almost totally destroyed, she managed to flee Europe with her husband. The couple arrived first at New York City, then moved on to Keene Valley, New York, where she took American citizenship and began teaching at the nearby state university in Plattsburg. She continued that association and residence until her death in 1990. Over her long career Winkel won four gold medals from the National Academy of Design. She was also named a fellow of the National Sculpture Society and in 1988 received that organization's Medal of Honor, its highest award.[1]

Winkel's creative work after coming to the United States was probably influenced by a small number of artists whom numerous critics and historians regard as the first truly modern sculptors in America. William Zorach, Robert Laurent and José deCreeft (all of whom, by the way, were immigrants) and South Dakota-born John Flanagan were active in New York from the late 1920s through the period of World War II, including the time Winkel arrived. Although she did not study with them directly, she would have been aware of the trends they introduced.

Zorach and the others advanced a design principle based on extreme simplification of natural form and retention of the essential mass and volume of the basic raw material. Winkel's Proskauer work largely follows these tendencies. The bronze, titled *Joy,* emphasizes weight and roundness, while the gently undulating contours create a rocking sensation.

1. See Barbara Lekberg's short but informative "Nina Winkel's Fulfillment ... Life in Sculpture," *Sculpture Review* 39, no. 2 (1990): 28-30.

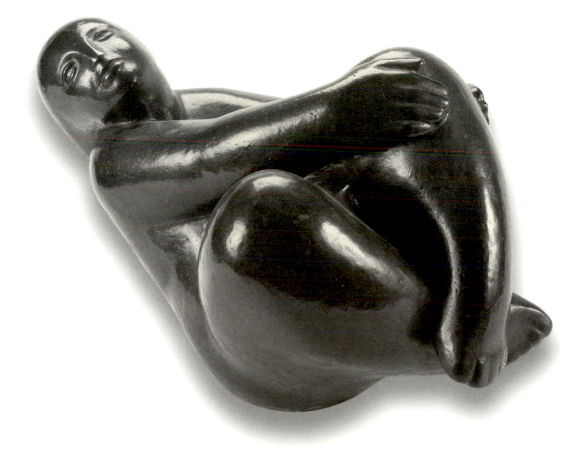

Joy, bronze (12 5/8 x 13 x 19 3/4"), 92.17.88

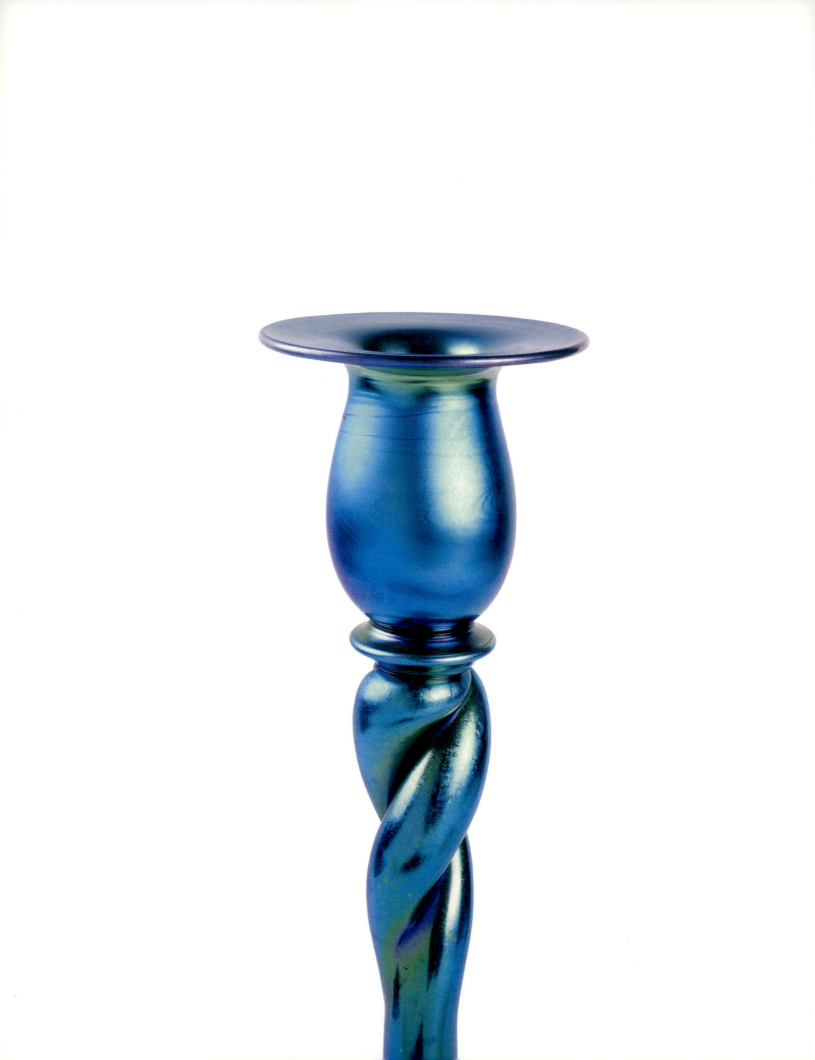

ART GLASS

The history of glassmaking reaches far back to ancient civilization. Long before the birth of Christ, glass was a known and precious commodity, and the simplest glass objects were regarded as a valued part of any fortunate owner's possessions in ancient times. It is also a medium of uncommon versatility. The successful glassmaker knows his medium well and understands what tendencies it possesses. By coaxing the material, a craftsman sometimes achieves his goal, creating something of beauty beyond utility.

Modern glassmaking employs techniques of manufacture similar to those of the oldest prototypes. In fact, much nineteenth- and twentieth-century art glass was intended to emulate the finest ancient glass. Such well known glass designers as Emile Gallé, Louis Comfort Tiffany and Frederick Carder looked to Egyptian or Roman glass for inspiration. What they learned from it was as different as what they themselves would create. Sometimes form was the primary consideration, but often the color of the glass mixture or surface decoration became the main concern. As always, glassmakers were as influenced by previous styles as by what they perceived to be current fashion. A few glassmakers sought new and unfamiliar shapes, preferring to break new ground in their search for beauty.

During the late Victorian era homeowners were anxious to decorate their interiors with furnishings inspired by Oriental, ancient and otherwise exotic objects, which were placed together and presented against a background of patterned fabrics, wall coverings and painted or finished woods to generate a sense of the owners' world consciousness. Within this period, some artists theorized about the absolute necessity of turning to nature for form and decoration, while others believed that truth and aesthetic success would surely be born from careful study of classical antiquity, medieval design or Far Eastern complexities.

By the third quarter of the nineteenth century such prominent artistic individuals as Emile Gallé (1846-1904) began to emerge on the glassmaking scene in France. Gallé's father, Charles Gallé-Reinemer, had been a glassmaker in Lorraine. Following early training from his father, Gallé studied fine arts in Weimar, Germany, and later traveled to London and Paris in his study of glass. By 1867 Emile Gallé had opened his own glassmaking facility in Nancy, and he was joined by his father in 1874.

The younger Gallé was an aesthetic revolutionary. He was innovative, radical and dedicated to the idea that in nature lay beauty and truth. His glass was entirely new. Decoration was integral to form and developed simultaneously. Gallé either made or would carefully oversee the production of each and every piece, retaining complete control over all the glass made under his name. For inspiration, Gallé looked to the ancient world; the cased cameo glass associated with his work, in fact, originated in Egypt.

Opposite: STEUBEN GLASSWORKS, *Candlestick* (detail), Blue Aurene glass (10 x 4 9/16"), 92.17.122 (see p. 101)

This extraordinarily creative artist found glass too limiting for his new design scheme. Generally referred to as Art Nouveau style, the sinuous natural expressions of his imagination were also manifested in wood furniture. His inlaid tables and glass-front cabinets were filled with glass pieces of his own design, producing a completely new interior inspired by floral, aquatic or mineral outgrowths. Gallé felt comfortable designing in media other than glass. His versatility was to inspire other designers such as the talented American, Louis Comfort Tiffany (1848-1933).

Tiffany's father was a noted New York jeweler. In 1869 he sent his son to Paris for continued training as a painter. While in Paris, Tiffany encountered the early work being done by Gallé and other proponents of the Art Nouveau movement. Tiffany made transparent, opaque and opalescent types of glass, which sometimes were combined into a single piece. His "pastel" glasses were used to make table wares, which included plates, finger bowls, compotes, stemware and vases to furnish the dining table. His *Favrile* glass was inspired by iridescence found on ancient Roman glass. Tiffany was fascinated by the richness of the glass of the ancient world being excavated throughout the Middle and Near East.

Both Gallé and Tiffany found that they needed to produce commercial grades of glass in order to remain independent enough to experiment. Tiffany's work extended from sensationally odd pieces that displayed extraordinary originality, to catalogue offerings produced in large numbers for less affluent customers with good taste. He enjoyed making glass of anti-aesthetic design. Today we see many examples of Tiffany glass that fall into the production category but only rare specimens of his most important work. Even the most frequently encountered conventional table wares, vases and lamps produced by Tiffany Studios were skillfully made and well conceived.

Tiffany, like his contemporary Gallé, was inspired to express himself in media other than glass. He was well known for his interior designs, which specified each design detail in woodwork, architectural elements, floor and wall coverings, furniture, lighting and decorative accessories, and was also a master of decorative motifs, form, color and surface. Tiffany borrowed from any source, foreign or domestic, ancient or modern, to create a total environment for his clients.

In both Europe and the United States, Gallé and Tiffany inspired followers. In some cases glassmakers or artisans who worked for these men would go out on their own to establish small independent firms. In most instances their products were less innovative but occasionally, nonetheless, well crafted. The Nouveau glasses offered by de Vez, Daum, La Verré Français, Muller and Delatte were highly decorative and sometimes even powerful. The Daum family was among the more successful and the glassworks is still in operation in Nancy, France, making extremely fine glass even today. Its success is owed to its ongoing employment of artists who have designed work relevant to their time.

While these artists were making their exotic and modern glass, many factories in Europe and America sought to offer their own fine glasswares. Large glass companies in the United States were competing for a broad segment of the glass market with new types of "art glass." In the East, the New England Glass Company in Cambridge, Massachusetts, and the Mt. Washington Glass Company in New Bedford were perfecting decorative lines of amazing variety.

Heat-sensitive glasses were among the most popular lines being made on a large scale during the 1880s. Mt. Washington patented *Burmese* glass in December of 1885. Frederick S. Shirley was the patentee, reserving production in America for his own company. Burmese was a homogeneous glass that shaded from yellow to pink when reheated during final stages of production. An entire line was offered by the firm, featuring primarily traditional forms inspired by classical glass and ceramics. Burmese was quite popular plain or decorated with rich painted enamels, applied jewels and gilding. It was offered in a natural glossy surface on a velvety acid-etched finish that was well suited for applied decoration.

Two other very popular heat-sensitive processes were *Amberina* and *Peach Blow*. Amberina was developed by Joseph Locke of the New England Glass Company in 1883. The process involved reheating sections of a clear amber glass containing a small amount of gold that turned those areas a deep red or purple; the unheated areas retained the original color. By combining an opalescent, opaque glass plated with a gold-ruby mixture and reheating it, *Plated Amberina* was produced. Amberina was extremely well received by the public and was copied by most of the larger glass factories. Peach Blow, which shaded from pink to white, was also developed at the New England Glass Company. The public fascination with oriental porcelains, specifically Chinese monochrome-glazed wares, most likely was the inspiration for this type of glass.

Much less radical than the glass made by Gallé or Tiffany, popular wares offered by large American glass factories became big sellers in a climate of aspiration for highly decorative and well-made fancy glass. The high end but somewhat conservative market was well-served by these and other American and English factories. They were, in their own way, innovative and diverse, always striving for new effects in glassware.

Not surprisingly, it was a British glass man who brought to Corning, New York, a blend of European conservativism and expertise. Frederick Carder came to America with a thorough knowledge of glass chemistry and manufacturing skills gained while art director at Stevens and Williams, where he was also a designer. A second generation glassmaker, Carder was steeped in English classical preferences. These guided the Steuben style under his direction from 1903 to 1933. Tiffany was still very active during these years, producing comparatively radical glass. Carder, on the other hand, designed strikingly conservative forms, colors and decorative effects in costly table wares, vases, lamps and even cast sculpture. His cut cameo glass was more literal than that made by Gallé. Although Carder's work was comparatively conventional, he designed hundreds of beautiful shapes and many superb color effects at Steuben. Steuben, under Carder's guidance, managed to blend sophistication and aesthetics with production and wider distribution. His work was well suited to the clean line of modern interiors.

While most glass manufacturing companies were struggling to make cheaper glass and more of it, a few were aspiring to the development of high-end "art glass." As distinguished from the single vision of the master glass artists such as Gallé and Tiffany, most American factories depended on key management and skilled craftsmen to develop new lines. In both Europe and America the majority of glassmaking concerns were established by businessmen with some artistic sense. The most important few were founded by artists with enough acuity to operate a business.

GALLÉ

One of Emile Gallé's most frequently practiced glassmaking techniques was an ancient method called cameo cutting, a method that originated in Egypt and had been used by the Chinese during the early eighteenth century. Broadly speaking, cameo glass always involves cutting away the surface to leave a design in relief. The "blank" (the original vessel) was made in color layers that anticipated selective surface reduction to reveal underlayers, color changes or eccentricities in the blank.

Historically, glassmakers had worked with decoration both as a part of the hot formation process and as cold work applied after the shape had been made and cooled. Gallé certainly used every method available to him to embellish his objects, but his most innovative pieces always merged decoration with form in an inseparable way. When he could, Gallé would apply bits of colored glass to the surface or within the body of the glass. Later he would liberate these added elements and reduce surface material by cutting it away.

The Proskauer Collection includes an outstanding example of Gallé's remarkable ability to place color bits on the surface of his cameo blank while it was being formed (see opposite page). The added bits (cabochons and silver metallic inclusions) were skillfully placed to anticipate later "cold" cutback decorative floral motifs in which the flower centers are three-dimensional and of a contrasting hue, a difficult and sophisticated decorative effect. The additions lend richness of color to a delicate range of hues and also give a sufficient three-dimensional quality to enhance the illusion of natural flora, jewels set in natural surroundings.

Typical of Gallé's output are the vases and bowl illustrated on pages 84 and 85. They represent the more naturalistic representation of flowers that he preferred. Vertical forms are suggestive of growth. On page 85, the designer has carved foliate vines against a gradually shaded background that suggests early morning light. In the shorter vase Gallé has chosen a different palette of deep purple browns against near white, a very different but effective contrast. The bowl has been altered around its rim, becoming more eccentric, less predictable and somehow more sculpture than vessel.

Vase, cameo glass (13 3/4 x 6 3/4"), 92.17.107

Vase, cameo glass (8 7/8 x 2 11/16 x 1 3/4"), 92.17.104

Vase, cameo glass (5 5/8 x 3 7/16"), 92.17.105

Bowl, cameo glass (1 13/16 x 7 5/16 x 5 9/16"), 92.17.101

Stick Vase, cameo glass (17 1/2 x 6 3/8"), 92.17.106

TIFFANY

Louis Comfort Tiffany is perhaps best known for his organic designs following the Art Nouveau aesthetic, such as the floraform vases in the Proskauer Collection (see pp. 87, 89 and cover detail). His interpretation of nature was, for the most part, less literal than Gallé's. He tended to capture the essence of plants, flowers, shells or insects, inferring a growing form by linear rhythms rather than literally reproducing the blossom, stem or leaf as surface decoration on a vase form. Page 89 shows typical free-hand formed glass that suggests organic forms.

Tiffany was, in large measure, indebted technically and aesthetically to the work of ancient glassmakers. The slender candlestick in the Proskauer Collection illustrated on the right on page 88, made of green glass blown into a bronze form, is similar in execution to an ancient beaker in the British Museum that was blown into a silver form. Tiffany made no secret of his fascination with ancient glass, admiring not only the techniques but the iridescent surface found on old glass when it has been buried for centuries.

Two floraform vases in the Proskauer Collection (see pp. 87, 89 and cover detail) are consummate examples of Tiffany's innate ability to merge form and decoration. These superb vases are flowers rather than vases with surface decoration in floral motifs. Their form is enhanced by inner coloration referred to as "feather pull-up" decoration. Technically this was achieved by wrapping the glass with threads of contrasting colored glass and pulling up and down to create feathered patterns on the surface, much like foliate veining.

Other outstanding examples from the Proskauer Collection that demonstrate Tiffany's ability to merge form and decoration are the two table lamps (see p. 91). The Lily lamp (at right) is one of Tiffany's most successful and popular creations. The other lamp is very different but also seems to be flowing in a natural blending of glass and metal.

Tiffany carried out his unique interior schemes at great expense for the affluent, but his vision also extended to a greater audience through catalogue offerings. He was ahead of his time in his marketing of good design. In the studio catalogues he offered, for example, bronze and glass desk sets described as "Abalone," "American Indian," "Ninth Century," "Venetian," "Chinese," "Adam," "Nautical," "Louis XVI" and "Zodiac." The Proskauer set (see p. 90) is a good example of the Zodiac style.

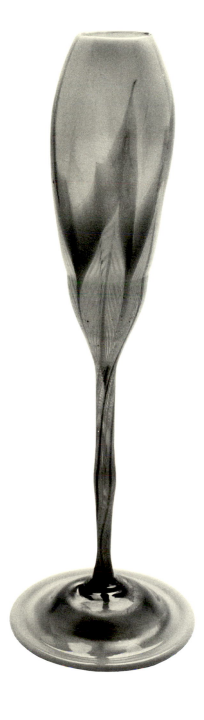

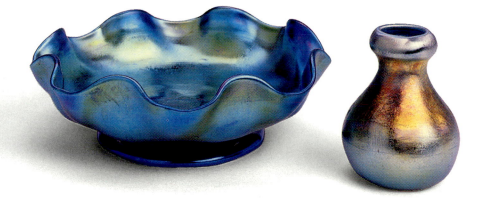

Left: *Finger Bowl*, Favrile glass (2 3/16 x 6 5/16"), 92.17.128

Center: *Vase*, glass (2 13/16 x 2 3/16"), 92.17.139

Right: *Floraform Vase*, glass (14 1/8 x 4 9/16"), 92.17.137 (see cover detail)

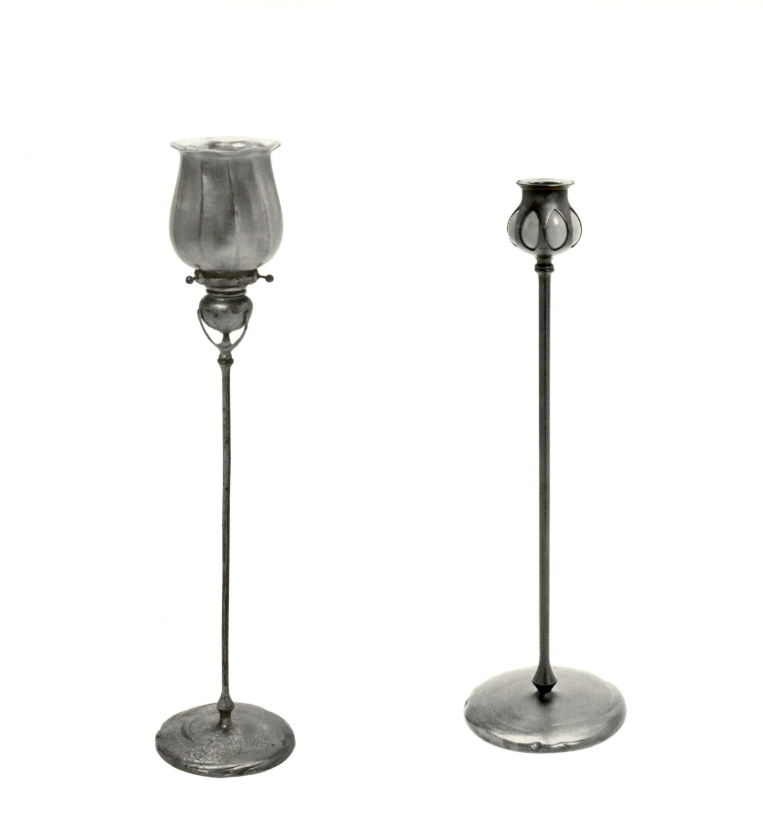

Candlestick, Favrile glass and gilded bronze (24 x 5 3/4"), 92.17.126

Candlestick, reticulated glass and bronze (17 1/8 x 5 7/16"), 92.17.125

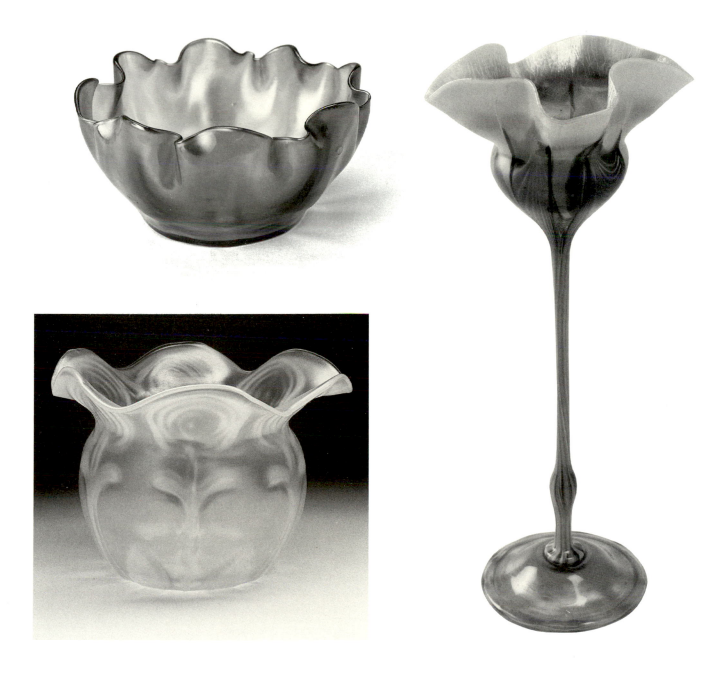

Top: *Bowl,* Favrile glass (2 5/16 x 4 1/2"), 92.17.129

Bottom: *Floraform Bowl,* Favrile glass (3 13/16 x 5 1/8"), 92.17.124

Right: *Floraform Vase,* glass (12 3/16 x 5 1/8"), 92.17.140 (see cover detail)

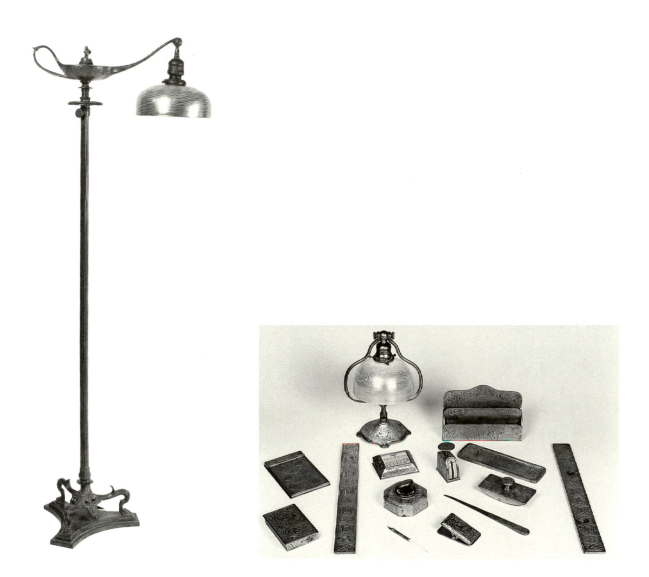

Floor Lamp, glass and bronze (54 11/16 x 12 1/4 x 19"), 92.17.135

Zodiac Desk Set (for information on individual objects, see Index), gilded bronze, 92.17.143.1-.13

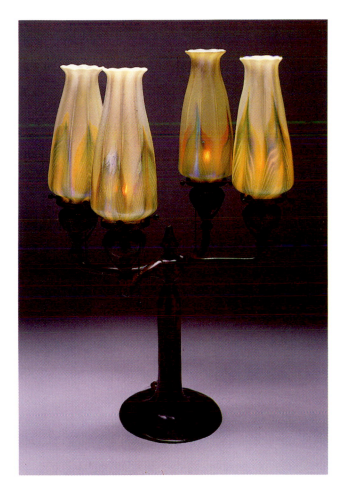 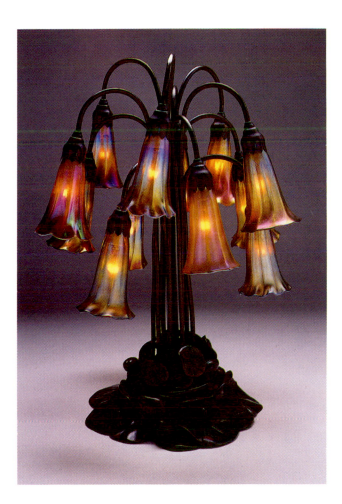

Table Lamp, glass and bronze (19 7/8 x 12 1/2 x 8"), 92.17.131

Pond Lily Table Lamp, glass and bronze (18 15/16 x 13 9/16"), 92.17.130

DAUM

The Daum family glassworks originated in 1879 and drew clear inspiration from Gallé and Tiffany. Originally from Lorraine, the family adopted the Cross of Lorraine as part of their factory mark, and it appeared on each piece of glass. Initially, Daum made only bottles, but they soon began making table glass decorated with gold. Not until about 1890 did they attempt cameo glass.

The Daum family was heavily influenced by Emile Gallé over the years. Gallé was involved with the art school in Nancy and had an impact on almost everyone working there at the time. The Daum glass took on Art Nouveau characteristics realized in acid cutback cameo rich in flowering natural motifs. Floral and animal forms as well as landscapes and seascapes were favorite themes and were represented by a variety of techniques.

Fine representative examples of Daum glass are shown on pages 93, 94 and 95. The small acid-etched lamp (see opposite page) with ball shade must have added considerable charm to its owner's room. While Daum's glass was heavily influenced by Gallé, it is generally more realistic in its decorative depiction of flowers, trees, insects, berries or leaves. It is also somewhat conservative when compared to work by Gallé.

A perfume bottle with silver cap (see p. 94) from the Proskauer Collection rivals the finest production of Gallé. The surface is three-dimensional with inclusions of multicolored glass powders, which add considerably to the interest and surface details. This is a rare and unusual example of Daum, typical of their best work.

At the turn of the century Daum experimented with free-blown vase forms with a wide base and a long, slender neck. Very difficult to produce, these vases were a tribute to the skill of the glass blower. Most were multi-colored, opaque and acid-finished as seen on page 95. Daum named these decorative forms *Berluzes*.

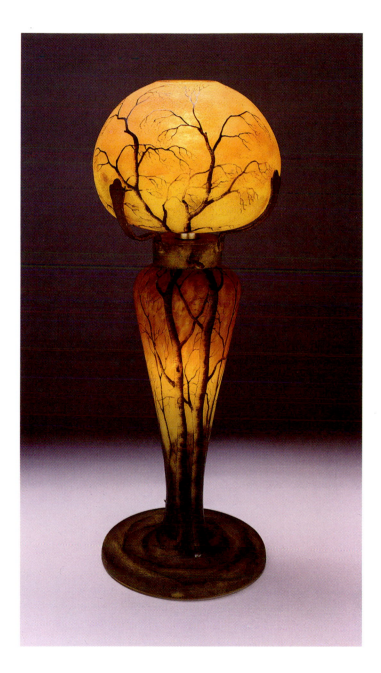

Table Lamp, acid-etched glass, enamel and brass (11 1/8 x 4 1/4"), 92.17.93

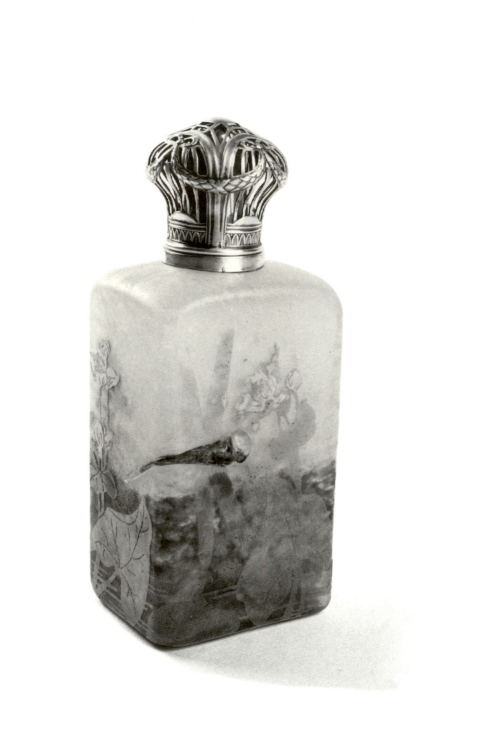

Scent Bottle, cameo glass, sterling silver and silverplate (7 x 3 x 2 7/16"), 92.17.91

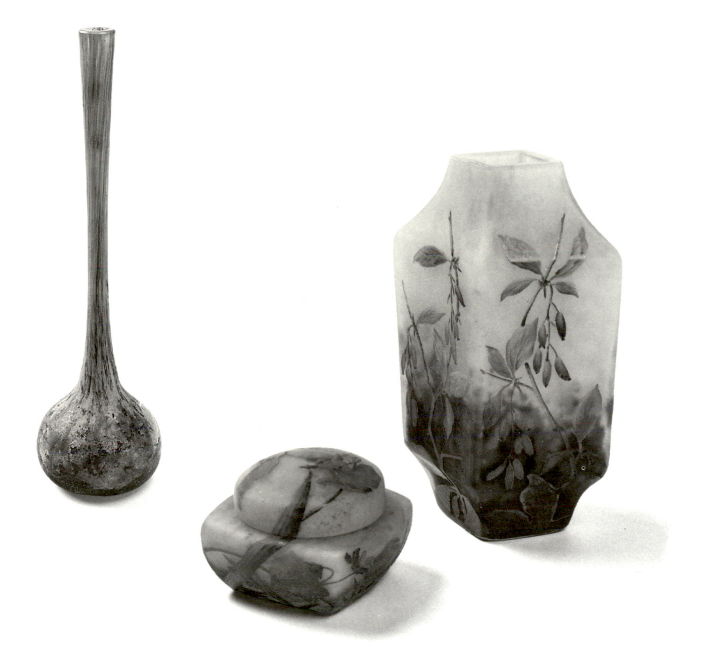

Left: *Vase,* Berluze acid-etched glass (7 1/8 x 2"), 92.17.153

Center: *Covered Box,* cameo glass (2 1/2 x 3 7/16 x 3 7/16"), 92.17.92

Right: *Vase,* cameo glass (7 x 4 11/16 x 3 9/16"), 92.17.94

NEW ENGLAND AND MT. WASHINGTON

In New England, two important companies producing art glass were the New England Glass Company in Cambridge, Massachusetts, and the Mt. Washington Glass Company in New Bedford, Massachusetts. These big glass facilities were staffed with talented chemists and designers whose ideas required skilled blowers and decorators to execute. Often the simplest designs required the most skill to produce.

Again, influence from ancient glass may be seen in the superb Burmese vase of the 1880s from the Proskauer Collection illustrated opposite. Made at Mt. Washington, this heat-sensitive glass vase shades from pink to yellow. The shape is reminiscent of ancient glass vials typical of the Roman Empire dating from about 100 to 300 A.D.

Another commercially successful heat-sensitive shaded glass at that time was developed and patented by Joseph Locke, assignor to W.L. Libbey and Edward D. Libbey in July 1883. Amberina was an amber glass that struck a fuchsia red when reheated in the furnace (called the "glory hole"). Most Amberina glass was blown, but much of it employed optic ribbing or a diamond optic transferred from a blow mold during the early stages of formation. The punch cup (see p. 98) is a good example of optic mold-blown Amberina. By casing it with opal or white on the interior, the rare Plated Amberina was created (see pp. 98 and 99). The New England Glass Company was the only producer of Plated Amberina. The lemonade glass and tumbler illustrate the effect of opal casing on Amberina.

Two lily vases in the Proskauer Collection (see p. 99) exemplify Peach Blow and Plated Amberina, both by the New England Glass Company. New England's version of Peach Blow shades from deep pink to white, differing from similar wares made at Mt. Washington, which shade from pink to pale blue. A similar glass called Wheeling Peach Blow was made by Hobbs, Brockunier and Co., but without optic ribs.

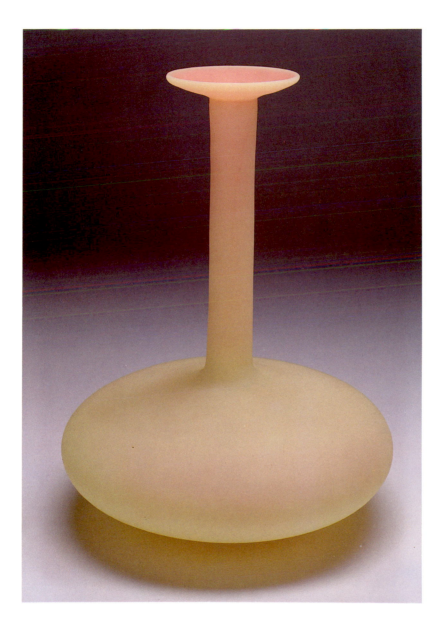

Vase, Burmese glass (7 3/16 x 5 1/2"), 92.17.110

Left: *Lemonade Tumbler,* Plated Amberina glass (4 3/4 x 3 1/16 x 2 7/16"), 92.17.114

Center: *Tumbler,* Plated Amberina glass (3 5/8" x 2 1/2"), 92.17.113

Right: *Punch Cup,* optic mold-blown Amberina glass (2 9/16 x 3 1/2 x 2 5/8"), 92.17.109

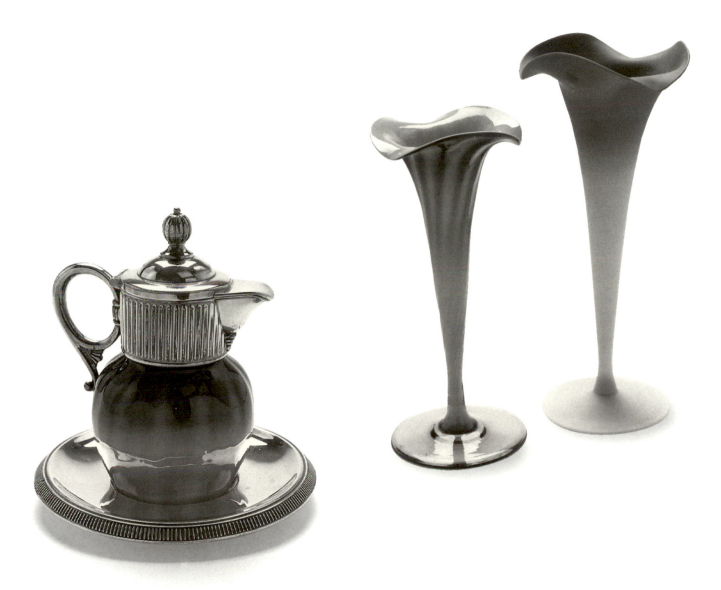

Left: *Syrup Pitcher* (on underplate), Plated Amberina glass and silverplate (5 7/8 x 5 5/8"), 92.17.112

Center: *Lily Vase,* Plated Amberina glass (8 15/16 x 3 7/16"), 92.17.115

Right: *Lily Vase,* Peach Blow glass (9 3/8 x 3 7/8"), 92.17.116

STEUBEN

Under Frederick Carder's direction, the Steuben Glassworks in Corning, New York, produced costly tableware, vases, candlesticks and lamps in a great variety of shapes, colors and surface finishes from 1903 to 1933, at which time the company reorganized and adopted its brilliant, trademark crystal. Carder's designs reflect his English classical taste and appear somewhat conservative next to Tiffany's work.

Carder loved pure colors to emphasize overall forms of simple design. He also developed Aurene glass, a type of iridescent glassware of blue and gold with surfaces similar to those of Tiffany's Favrile. Sometimes this glassware was blown into molds to create a patterned optic surface.

The candlesticks illustrated on the right are typical examples of Steuben's Aurene glass. Aurene was in direct competition with Tiffany's Favrile line. Both glassmakers used deep blue and amber glass for their iridescent wares. Over this colored glass they created a rich iridescence by exposing it, while still hot from forming, to metallic salts. Surface molecules on the glass, disturbed by the chemicals, broke up reflected light and caused a prismatic surface. The effect was a lavish iridescent color emulating ancient glass.

The fan vase (see opposite) in clear green glass was an extremely popular shape in Steuben production. Carder used ordinary transparent colors for many of his shapes. Amber, deep yellow, ruby and celeste blue were favorite shades for table glass. Sometimes two colors were used on the same piece to heighten the drama of form.

Left: *Fan Vase,* optic mold-blown glass (8 7/16 x 6 15/16 x 3 7/8"), 92.17.123

Center: *Candlestick,* Gold Aurene glass (3 11/16 x 4 1/16"), 92.17.120

Right: *Candlestick,* Blue Aurene glass (10 x 4 9/16"), 92.17.122 (see detail on p. 78)

LATE FRENCH CAMEO

From 1890 to 1930, glassmakers influenced by the great designers Gallé and Tiffany were busy making glass at their own various locations. Such men as Henri Muller and his brother Désiré working near Luneville (Lorraine) were from the Gallé tradition and, in fact, did their early work at Gallé's Nancy workshop in the 1880s. Constantly experimenting with decorative techniques, they could carve expertly and use hydrofluoric acid to produce extremely subtle effects. Page 103 features a representative example of Muller work.

The vase on the near left (see opposite) is by André Delatte, who founded a small glassworks at Nancy in 1921. Influenced by both Daum and the Muller brothers, Delatte made cameo glass that is almost entirely layered and acid cut. Delatte works are always signed "A Delatte Nancy," as is the Proskauer vase.

Page 104 is an example of cameo glass produced by Le Verre Français. Its rather distinctive style is characterized by the customary use of only two layers with a single acid cutting and by the layers (thinner outside and thicker inside) being mottled in appearance.

The vase on page 105 is signed "de Vez," the product of a company founded in 1850 at La Villette near Paris (it later moved to Pantin, now part of Paris). The firm's art director, a Monsieur de Varreux, signed many pieces "de Vez"; other works from the company bear the names "Mont Joye" and "Pantin."

Left: DELATTE, *Vase,* cameo glass (8 5/8 x 7"), 92.17.95

Right: MULLER BROTHERS, *Vase,* cameo glass (16 3/16 x 7 13/16"), 92.17.111

LE VERRE FRANÇAIS, *Vase*, cameo glass (7 7/8 x 5 1/8"), 92.17.154

104

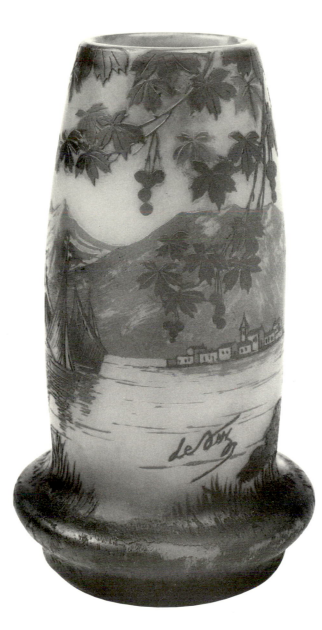

DE VEZ (PANTIN GLASSWORKS), *Vase,* cameo glass (7 3/4 x 4 9/16"), 92.17.96

DECORATIVE ARTS, TOYS & FOLK ARTS

The Proskauers' diverse collecting interests extended to a wide variety of decorative and folk arts (in addition to their extraordinary art glass collection). They acquired American textiles, weather vanes, whirligigs, folk sculpture, table and mantel ornaments, baskets, ceramic wares, and all kinds of antique toys, including delightful penny banks with ingenious moving parts designed to make saving money an enjoyable pastime.

The Proskauers also built a small but select holding of Far Eastern objects, including a fine Chinese Coromandel lacquer screen, a jade carving, incense burners, and porcelain, stoneware and metal vessels.

Chess sets were certainly one of the Proskauers' more absorbing pursuits. They acquired seventeen sets—outstanding examples from Africa, Asia, Europe, Mexico and the United States. In materials ranging from ivory and wood to glass crystal, the sets show the remarkable craftsmanship of the various makers. Additionally, the costumes and physical features of the game pieces provide a glimpse of the cultures represented.

Opposite: AMERICAN, Unknown, *Coverlet* (detail), mid-19th century, natural cotton and dyed wool (77 1/4 x 86 1/8"), double cloth technique woven on a hand loom with Jacquard attachment, 92.17.168 (see p. 116)

ORIENTAL DECORATIVE ARTS

The museum's handsome Chinese Coromandel floor screen (see p. 110) from 1840 features a fanciful garden on each side. The front shows a budding tree (symbolizing spring and new life) surrounded by several plant varieties, including rose, lotus, chrysanthemum and bamboo. Herons, pheasants, and numerous flying doves and songbirds enliven the scene. A flowering vine border surrounds the overall view. The wood was finished with several coats of a special dark lacquer, then portions of the surface layer were carved away to reveal pictorial and decorative designs. Those designs, in turn, were painted in with contrasting colors. Coromandel (or Coromandle) works take their name from the Coromandel Coast of southeastern India, the route along which the items formerly were exported to Europe and America.

Tea drinking in China and Japan, as the Proskauers undoubtedly appreciated, is more than just taking refreshment or relieving thirst. Customarily it is an occasion to savor the subtleties of flavor and to appraise the quality of the blend. Two vessels in the collection were originally used at such times. The small Japanese iron kettle (see p. 111), dating to the Edo period, has the so-called "hailstone" convex dot pattern encircling the side. The lid handle in the form of a pinecone, a symbol of longevity, subtly extends the wish for long life to the one who drinks. This kettle would have been used to heat water on a brazier of coals, then, in most cases, to transfer the hot water to smaller pots for steeping the tea.

The Chinese Yixing teapot (see p. 112), probably dating from the Ch'ing dynasty, is such a smaller vessel. Yixing, a region of east-central China, is known for a local reddish- or purplish-brown clay that has proven especially well-suited for pottery. With kiln-firing, the clay becomes remarkably durable. Even without glazing, it is almost as smooth and hard as porcelain. In fact, Yixing potters ordinarily leave the ware unglazed so that the distinctive color continues to show. Both the Chinese and the Japanese, as well as many Western tea enthusiasts, consider Yixing pots superior for brewing tea and for sustaining aroma and flavor.

Embossed and incised designs decorate this teapot. The spout becomes a dragon's long neck and head, and stylized dragons are built up on the handle and lid as well. (To the Chinese, dragons, despite their fierce appearance, represent benevolent forces.) After shaping the vessel, but before the clay fully dried, the ceramist used a punch-like stamp to impress a diagonal grid pattern around the mid-section, over which a thin greyish-brown stain was applied for added effect.

A small jade carving in the Proskauer Collection recalls a centuries-old Chinese proverb: "A scholar should revere the truth as he reveres jade." That a writer might contemplate or be reminded of the truth, decorative objects like the *Two Entwined Chimeras* (see p. 112) were often part of the traditional scholar's desk setting (which also included stamp seals and writing implements). An imaginary beast in traditional Chinese lore, a chimera is a combination of lion and eagle and is seen as a personal guardian or protector.

Rarity is a prime reason the Chinese revere jade. Most raw jade has been imported over several thousand miles to the principal craft centers. Also, because the material is extremely hard, it is difficult and challenging to carve. A craftsman might work several months on a small ornament and several years on a larger or more intricately composed work.

The Proskauers must have been intrigued by an ingenious decorative object designed to measure time without weights, springs, gears or other movable parts. As early as the seventh century the Chinese conceived a device based on the principle that incense will burn measured amounts at a predictable rate. Incense "clocks" remain popular in China, even though they have been outmoded since mechanical timepieces were introduced in the sixteenth century.

Although incense clocks take numerous shapes and sizes (the square or rectangular box being the most typical), their functions are essentially alike. Each has an internal compartment into which a powdered incense is carefully placed along a continuous grooved track. The incense is ignited at a beginning point, after which time intervals can be measured by the progression of the burn. A lid with cut-out designs fits over the compartment. It serves as a grill to control air admitted to the inner chamber, to assure an even burn, and to release fragrance to the outside.

The museum's white copper incense clock (see p. 113), from the nineteenth century, is in the shape of a *ju-i* scepter, derived from the *ling chih,* or "plant of long life," a particular kind of edible fungus that the Chinese prize highly for health and medicinal properties. The motif has symbolic meaning as an emblem of longevity. While the exterior shape of the museum's smaller brass *ju-i* is similar, strictly speaking it is only a burner because its incense track does not diagram a continuous measured pattern.

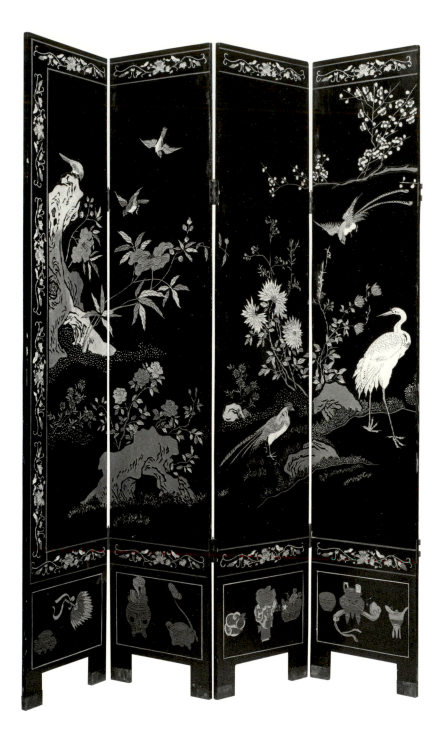

CHINESE, *Coromandel 8-panel Floor Screen,* 1840, carved, painted and
lacquered wood (84 1/8 x 128 x 3/4"), 92.17.171

110

JAPANESE, *Kettle,* cast iron (9 9/16 x 7 7/8 x 5 3/4"), 92.17.175

111

CHINESE, *Teapot,* Yixing stoneware (4 1/8 x 8 1/4 x 5 3/16"), 92.17.57

CHINESE, *Two Entwined Chimeras,* jade with wood stand (3 x 3 13/16 x 3/8"; stand: 2 1/2 x 4 3/16 x 1 7/16"), 92.17.170

Top: CHINESE, *Incense Clock*, 19th century, white copper and brass (2 13/16 x 11 5/8 x 3 1/8"), 92.17.173

Bottom: CHINESE, *Incense Burner*, 19th century, brass (1 3/4 x 9 7/16 x 2 1/4"), 92.17.172

Among the splendid works of American folk art and craft the Proskauers acquired is a mid-nineteenth-century coverlet (see p. 116) made from homespun natural cotton and indigo-dyed wool. The elaborate pattern of large and small floral medallions, delicate rosettes and double blossoms shows the Jacquard loom's capability for intricate design detail and complexity. Earlier in the century, Frenchman Joseph Marle Jacquard perfected an apparatus that revolutionized woven cloth production. By 1824 his loom attachments were marketed in the United States, and by mid-century hundreds of small professional shops were using the invention to produce tapestries, damask, brocades and coverlets. Pattern books were available that directed the loom settings for an almost limitless variety of design motifs including flowers, animals, birds, scrolls, landscape elements, buildings, crests, monograms and words.

Quilts are about the showiest of the conservative Amish religious group's personal possessions, and many examples present intense, even bright colors. But others, like the one the Proskauers collected (see p. 117), use more subdued tones: black, grey, blue-grey, navy, sometimes dark green or maroon. Patterns are fashioned by piecing together simple geometric squares, rectangles and triangles. Orderly designs feature checkered panels, often set on a forty-five degree diagonal, as seen in the museum's example.

The Proskauers' informal dining room at their ante-bellum Buck Pond Farm home had surrounding plate rails and shelves that offered an ideal display place for the antique toys they began acquiring in the mid-1970s. Their collection shows how American toys in many ways tell the history of the nation. From the colonial period to the Civil War, when the United States was predominantly rural and unindustrialized, toymaking was chiefly a family craft or local folk tradition. Many German-immigrant craftsmen fashioned toys in the mid-nineteenth century, including Wilhelm Schimmel of Carlisle, Pennsylvania, who became widely known for his distinctive, spontaneously carved and painted animals in pine. The museum's *Crow* and *Cow* (see p. 118) from the Proskauer Collection, if not by Schimmel himself, certainly show Schimmel or the German-immigrant influence.

Hand-crafted toys often show the maker's whimsy. One would expect burly oxen to pull the *Pioneers in a Conestoga Wagon* (see p. 119), a fabric, metal and painted wood toy from about 1880, but these particular beasts resemble Holstein cows. Again, the subject speaks of an epoch in American history, the tedious overland migration of settlers to the West that reached its height in the 1860s and 1870s.

With America's expanding industrialization and urbanization in the last decades of the nineteenth century, commercially made tin and cast iron toys became popular. Mechanical and mobile toys were especially so, reflecting the era's growing fascination with machinery, speed and motion. The museum's *Horse-drawn Fire Engine* (see p. 119) and *Seated Man and Woman with Paddle* (p. 120) from about 1900, are fitting examples. Though more a shelf or mantel ornament, the wood-carved *Man at Machine from E. J. Shoe Company* (see p. 120) again presents the theme of industrialization.

Before the science of weather forecasting improved in the twentieth century, weather vanes were essential devices to help anticipate storms that might adversely affect such important tasks as farming and fishing. European colonists brought the millennia-old vane-making craft to America, where it flourished as both a folk and a manufactured art form. Many thousands were produced. The museum's *Hunting Dog Weather Vane* (see p. 121), cut from sheet metal, probably dates from the late nineteenth century. The setter or pointer dog presents a definitive silhouette, an important consideration in vane design. Characteristically, figures or animals face into the wind. Here the dog also stands amid blades of grass that appear to bend from the breeze. Most vanes were mounted over a horizontal rod-cross with end components that indicate compass directions, usually the letters N, E, S, and W.

Coverlet, mid-19th century, natural cotton and dyed wool (86 1/8 x 77 1/4"), double cloth technique woven on a hand loom with Jacquard attachment, 92.17.168 (see detail on p.106)

Amish, *Quilt,* 1902, pieced cotton (72 1/2 x 88 1/2"), 92.17.169

Crow, polychrome wood (8 1/16 x 2 1/4 x 3 13/16"), 92.17.157

Cow, polychrome wood (3 9/16 x 7 1/8 x 1 15/16"), 92.17.156

118

Pioneers in a Conestoga Wagon, polychrome wood, fabric, and metal (12 x 27 11/16 x 8 3/4"), 92.17.159

Horse-Drawn Fire Engine Toy, polychrome cast iron (7 1/16 x 19 3/4 x 5 5/8"), 92.17.166

Seated Man and Woman with Paddle Toy, polychrome wood and metal (17 1/4 x 12 1/4 x 7 1/16"), 92.17.162

Man at Machine from E.J. Shoe Co. ('Efficiency in the Rough'), wood (7 5/8 x 13 7/8 x 8"), 92.17.158

Hunting Dog Weather Vane, polychrome ferrous metal (40 1/2 x 45 15/16 x 2"). 92.17.167

CHESS SETS

The Proskauers' remarkable collecting interests included seventeen chess sets, with examples from Africa, Asia, Europe, Mexico and the United States. Two especially fine sets are illustrated in the catalogue.

Chess is one of the oldest board games in the world, with origins as far back as seventh-century India and possibly earlier. Initially the game was a strategic contest of symbolic armies for four players. By the eighth century it had evolved to resemble the present-day, two-player game with codified rules that have changed little since that time. Mainly through trade and diplomatic contact, the increasingly popular game moved both east and west from India. By the tenth century, Persians and later Arabs had introduced chess to Europe.

The stock gamepiece characters—king, queen, bishop, knight, rook, and pawn—have lent themselves over the years to an enormous range of interpretation and depiction, given the diverse cultures, religions, political systems and geographic situations of the players. Over the years, too, many materials have been used to fashion chess pieces: wood, ivory, bone, marble, precious stone, porcelain, ceramic, rock crystal, glass, various metals and, in the twentieth century, plastic. Unfortunately, few sets or pieces predating the seventeenth century survive, although numerous medieval illustrations show people at gameboards and the types of pieces utilized.

Dieppe, a port town on the Normandy coast in northern France, was home to several chess-set carving shops in the seventeenth, eighteenth and early nineteenth centuries, and a distinct style can be identified. The individual characters are busts, set on pedestals that rise from a flat base. Heads are usually turned to one side or cocked in jaunty positions. The bishop piece is not a churchman but a nobleman who wears a tricorn or conventional hat with wide brim. The rook's masonry joints are deeply incised and well defined. All these features are evident in the museum's set (see opposite).

Because glass chess pieces are easily broken, such sets are usually collected for display rather than actual playing. America's Steuben company produced the handsome deep cobalt blue and clear glass set (see opposite). These molded pieces are probably fashioned after sets first issued earlier this century in France by Vilery Crystal Company. The actual shapes, however, are based on "Staunton" style chessmen, named for the mid-nineteenth-century British champion who endorsed them. The simplified, easily recognized pieces, designed in 1935 by Nathaniel Cooke of London and patented in 1849 by the Jacques of London toy firm, have subsequently become a worldwide standard type.

FRENCH (Dieppe style), *Chess Set*, probably 18th century, polychrome ivory
(ranging from 1 5/8 x 1 1/16" to 2 7/8 x 1 1/16"), 92.17.190.1-.32

STEUBEN GLASSWORKS, *Chess Set*, 20th century, molded glass
(ranging from 1 13/16 x 15/16" to 3 x 1 1/4"), 92.17.197.1-.32

INDEX OF WORKS
IN THE PROSKAUER COLLECTION

An "E" following an entry indicates inclusion in the exhibition.
A "C" following an entry indicates inclusion in the catalogue.

Dimensions in inches are listed in order of height, width for 2-D objects and
height, width, depth or height, diameter for 3-D objects.

PAINTINGS AND WORKS ON PAPER:

MILTON AVERY (American, 1893-1965), *Dune Bushes,* 1958, oil on buff wove paper (18 x 24"), 92.17.2—E

MILTON AVERY (American, 1893-1965), *Firs and Pale Field,* 1943, watercolor on off-white wove paper (22 3/4 x 30 7/8"), 92.17.1—CE

MILTON AVERY (American, 1893-1965), *Green Sea,* 1958, oil on canvas (18 x 24"), 92.17.4—CE

MILTON AVERY (American, 1893-1965), *Sunbathers by Rippled Sea,* 1945, watercolor on off-white wove paper (22 5/8 x 30 15/16"), 92.17.3—E

LUDWIG BEMELMANS (American, b. Austria, 1898-1962), *Fox in a Box,* casein on panel (22 x 16 3/8"), 92.17.5—E

LUDWIG BEMELMANS (American, b. Austria, 1898-1962), *Madeline and Pepito,* oil on panel (29 15/16 x 24 1/8"), 92.17.6—CE

LIVIO BERNASCONI (Italian, b. Switzerland, b. 1932), *Scolo Merci,* 1957, oil on canvas (39 3/8 x 19 7/8"), 92.17.7—E

JULIUS BISSIER (German, 1893-1965), Untitled, 1961, oil and tempera on linen (7 15/16 x 10"), 92.17.8—CE

BERNARD BUFFET (French, b. 1928), *Coffee Grinder and Basket,* 1958, oil on canvas (22 x 14 3/16"), 92.17.9—CE

CHINESE, Untitled (Horse), watercolor and ink on paper (8 5/8 x 10 1/4")

JOSE LUIS CUEVAS (Mexican, b. 1934), *Two Women,* 1953, watercolor, color pencil and gum arabic on buff wove paper (15 1/4 x 11 5/8"), 92.17.10—E

BRUCE CURRIE (American, b. 1911), *Bather,* oil on canvas (10 1/8 x 8 1/8"), 92.17.11

BRUCE DORFMAN (American, b. 1936), *Cornflowers,* oil on canvas (34 x 24"), 92.17.13

BRUCE DORFMAN (American, b. 1936), *Mantilla,* oil on canvas (36 x 22 1/8"), 92.17.12

JEAN DUBUFFET (French, 1901-1985), *Bon Voyage,* 1955, oil on canvas (23 3/4 x 28 3/4"), 92.17.14—CE

JEAN DUBUFFET (French, 1901-1985), *La Chope (The Beer Mug),* 1966, felt marker on off-white wove paper (9 13/16 x 6 1/2"), 92.17.15—CE

ARSHILE GORKY (American, b. Armenia, 1905-1948), *Woman with Necklace* (Studio version), 1936, oil on canvas (20 x 16 1/8"), 92.17.18—CE

MORRIS GRAVES (American, b. 1910), *South American Brush Hen, Bronx Zoo,* 1937, pencil on buff wove paper (8 7/8 x 11 15/16"), 92.17.19—CE

KARL HOFER (German, 1878-1955), *Three Boys with Ball,* 1943, oil on canvas (29 3/4 x 20"), 92.17.20—CE

MANUEL HERNANDEZ ACEVEDO, *Female Nude,* 1958, oil on masonite panel (19 1/8 x 11 1/8"), 92.17.21—E

JIM HOUSER (American, b. 1928), *Mailbox III,* 1967, oil on canvas (49 3/4 x 48 5/8"), 92.17.22—CE

LESTER JOHNSON (American, b. 1919), *Two Young Men Facing Left,* 1964, oil on canvas (30 x 40 1/8"), 92.17.23—CE

SIDNEY LAUFMAN (American, b. 1891), Untitled (Trees), gouache on buff wove paper (8 1/2 x 10 15/16"), 92.17.24

A. LONGENT, Untitled (Horse), ca. 1849, watercolor on cream laid paper (6 5/16 x 7 7/8")

A. LONGENT, Untitled (Three soldiers), 1849, watercolor on cream laid paper (7 3/8 (irregular) x 6 3/8")

LUCEBERT, also known as JEAN LUCEBERT (b. Lucebertus J. Swaanswijk) (Dutch, b. 1924), *Warriors,* oil on canvas (39 1/2 x 55 1/8"), 92.17.25—CE

PEPPINO MANGRAVITE (American, 1896-1978), *Tomorrow's Bread,* 1943, lithograph on off-white wove paper (image: 8 1/4 x 13 3/8"; sheet: 11 1/16 x 16"), 92.17.26

JOHN MARIN (American, 1870-1953), *Looking Outward,* 1921, watercolor with chalk on cream wove paper (14 x 17"), 92.17.27—CE

MARINO MARINI (Italian, 1901-1980), *Blue Horse and Rider,* 1955, oil and enamel on buff wove paper (33 7/8 x 24 1/2"), 92.17.28—CE

FLETCHER MARTIN (American, 1904-1979), *Boy with Crab,* oil on canvas (28 1/8 x 11 1/2"), 92.17.16—E

FLETCHER MARTIN (American, 1904-1979), *Mexican Girl,* oil on canvas (32 1/8 x 24"), 92.17.17

HENRY MATTSON (American, b. Sweden, 1887-1971), *Full Moon,* oil on canvas (25 1/8 x 32 1/4"), 92.17.29

HENRY MATTSON (American, b. Sweden, 1887-1971), *Seascape,* oil on canvas (12 1/8 x 16 1/8") 92.17.30

HENRY MATTSON (American, b. Sweden, 1887-1971), *Wildflowers,* 1964, oil on canvas (20 1/8 x 30 1/8"), 92.17.31

ZYGMUND JOSEPH MENKES (American, b. Poland, 1896), *Poppies,* oil on canvas (28 1/8 x 19 1/4"), 92.17.32

VILLORO BENITO MESSEGUER (American, b. Spain, 1930), *Cabeza,* 1965, mixed media on cream wove paper (25 5/8 x 12 5/8"), 92.17.33

JOAN MIRÓ (Spanish, 1893-1983), *Constellations d'une Femme Assise,* ca. 1937, ink on cream wove paper (24 7/16 x 19 3/16"), 92.17.35—CE

JOAN MIRÓ (Spanish, 1893-1983), *Personnages, Oiseau,* 1942, pastel and watercolor on cream wove paper (20 3/8 x 26 1/4"), 92.17.34—CE

OTTO MUELLER (German, 1874-1930), *Seated Nude,* ca. 1930, lithograph on buff wove paper (image: 10 5/8 x 8 1/4"; sheet: 16 3/4 x 13 3/8"), 92.17.36—CE

GIORGIO DARIO PAOLUCCI, *Collina,* oil on wood panel (23 5/8 x 31 3/8"), 92.17.37

JULES PASCIN (b. Julius Pincas) (American and French, b. Bulgaria, 1885-1930), *Nude (Growing),* 1914-16, oil on canvas (23 5/8 x 36 1/4"), 92.17.38—CE

ROBERT PHILIPP (American, 1895-1981), *Rendez-vous,* oil on canvas (10 x 12 1/8"), 92.17.40

ROBERT PHILIPP (American, 1895-1981), *Showgirls,* oil on canvas (30 1/8 x 36 1/4"), 92.17.41—E

PABLO PICASSO (Spanish, 1881-1973), *Mère et Enfant,* 1920, pencil on cream wove paper (10 3/4 x 8 3/16"), 92.17.42—CE

EDWARD RUSCHA (American, b. 1937), *Foil,* 1971, pencil, gunpowder and pastel on cream wove paper (11 9/16 x 27"), 92.17.43—CE

KARL SCHMIDT-ROTTLUFF (German, 1884-1976), *Afternoon Sun,* 1959, watercolor on off-white wove paper (19 3/4 x 27 3/16"), 92.17.44—CE

WILLIAM SCHOCK (American, b. Brazil, 1913), *Landscape,* oil on canvas (14 1/4 x 19 3/4"), 92.17.45

ALAN SHIELDS (American, b. 1944), *Sillie Pupping,* 1971, acrylic on canvas (35 3/4 x 35 5/8"), 92.17.46

RAPHAEL SOYER (American, 1899-1987), *Reclining Nude,* oil on canvas (10 1/8 x 16 1/4"), 92.17.47—CE

UNKNOWN (English School), *Loch Nevis,* 20th century, oil on board (14 x 18"), 92.17.48

UNKNOWN, Frontispiece from *Syntagma Anatomicum* by Joannis Vesling, 1659, engraving on cream paper (8 9/16 x 6 7/16")

UNKNOWN, *Portrait of Marquardi and Froeri,* engraving on cream laid paper (6 15/16 x 8 3/8")

LARRY ZOX (American, b. 1936), *Diamond Drill,* 1967, Acrylic on canvas (19 1/8 x 16"), 92.17.49—CE

SCULPTURE:

KENNETH ARMITAGE (British, b. 1916), *Two Seated Figures* (Version A), 1957, bronze (10 15/16 x 14 5/8 x 9 5/8"), 92.17.50—CE

WOLFGANG BEHL (American, b. Germany, b. 1918), *Lovers,* 1960, bronze (22 1/16 x 8 1/8 x 6 11/16"), 92.17.52

JOACHIM BERTHOLD (German, b. 1917), *Seated Man,* 1962, bronze (10 11/16 x 17 15/16 x 6 1/4"), 92.17.53—E

HARRY BERTOIA (American, b. Italy, 1915-1978), Untitled, 1968, bronze (30 5/8" x 7 15/16 x 8 15/16"), 92.17.54—CE

ALEXANDER CALDER (American, 1898-1976), *The Star,* 1960, polychrome sheet metal and steel wire (35 3/4 x 53 3/4 x 17 5/8"), 92.17.55—CE

EDWARD ARCENIO CHAVEZ (American, b. 1917), *Citadel,* brass, copper and sandstone (21 5/16 x 18 3/8 x 6"), 92.17.58

DAVID E. DAVIS (American, b. Romania, 1920), *Interlude,* 1981, black and white marble (17 3/4 x 13 15/16 x 9 1/4"), 92.17.60—CE

WILLIAM DAVIS, *Thermal Relaxation,* 1968, plexiglas (8 11/16 x 18 13/16 x 17 5/8"), 92.17.59

RONALD DREFFER, *Laser Sculpture,* 1970, plexiglas, plastic laminate, wood, electric wiring and light bulb (25" x 5 x 4 7/8"), 92.17.61

DONALD DRUMM (American, b. 1935), Untitled, aluminum (10 5/8 x 5 x 8 5/8"), 92.17.62

DONALD DRUMM (American, b. 1935), Untitled (Three figures on a horse), bronze (12 11/16 x 12 9/16 x 3 13/16"), 92.17.63

MANUEL FELGUEREZ (Mexican), Untitled (Horse and jockey), polychrome steel (13 x 11 3/16 x 4 9/16"), 92.17.64

ART JONES (American, b. 1945), *Alligator and Tree,* 1980, polychrome wood (13 7/16 x 8 3/4 x 6 7/8"), 92.17.65

FRITZ KOENIG (German, b. 1924), *Asinello,* 1953, bronze (32 7/8 x 16 5/16 x 15"), 92.17.66—CE

GEORG KOLBE (German, 1877-1947), *Sigende,* 1931 (Cast #3), bronze (23 1/8 x 14 1/8 x 18 1/8"), 92.17.67—CE

WILLIAM MCVEY (American, b. 1905), *Thinker,* ceramic (10 11/16 x 6 7/8 x 6 3/8"), 92.17.70

PIERRE-JULES MÊNE (French, 1910-1879), *Greyhound,* bronze and marble (8 1/16 x 11 1/8 x 5 1/4"), 92.17.71

LOUISE NEVELSON (American, b. Ukraine, 1899-1988), Untitled, polychrome wood and plexiglas (15 3/8 x 19 5/8 x 4 7/8"), 92.17.72—CE

NEW GUINEA, Maprik, *Ancestral Figure,* polychrome wood (42 15/16 x 13 1/2 x 8"), 92.17.73

MISKA PETERSHAM (American, b. Hungary, 1888-1959), *The Dancers,* unglazed ceramic (20 x 17 15/16 x 16 1/16"), 92.17.74

PABLO PICASSO (Spanish, 1881-1973), *Plate,* glazed ceramic (1 1/2 x 16 7/8"), 92.17.75—E

CHUCK PRENTISS (American, b. 1942), *Twelve by Twelve Square,* 1971, glass, stainless steel, electric motor, and light bulbs (12 3/8 x 12 1/8 x 8 7/8"), 92.17.76—E

GEORGE RICKEY (American, b. 1907), *Forty Squares—Two Solids,* stainless steel (12 13/16 x 24 1/8 x 15 5/8"), 92.17.77—E

GEORGE RICKEY (American, b. 1907), *Little Sedge,* 1961, stainless steel (21 1/16 x 6 13/16 x 4 1/2"), 92.17.79—CE

GEORGE RICKEY (American, b. 1907), *Two Lines Oblique,* 1967-69, stainless steel (27'1" x 34'2" x 31 1/8"), 92.17.78—CE

VIKTOR SCHRECKENGOST (American, b. 1906), *Caw, Caw,* ceramic and steel (15 3/16 x 6 1/2 x 8 15/16"; 15 1/2 x 6 7/8 x 8 7/8"; 12 3/8 x 5 x 8 7/8"; 13/16 x 5 3/8 x 11 13/16"; 14 1/4 x 4 7/8 x 11"), 92.17.80.1-.5

HANNAH L. SMALL (American, b. 1908), *Pink Dancer,* pink marble (32 13/16 x 10 3/16 x 10"), 92.17.82—CE

JAMES STUCKENBERG, *Twice a Millionaire,* bronze and marble (9 5/8 x 17 3/8 x 6 9/16")

EDGAR TAFUR (Colombian, b. 1929), *Dandelion,* brass and copper (38 7/8 x 34 1/2 x 13 9/16"), 92.17.83

EDGAR TOLSON (American, 1904-1984), *Temptation Scene,* 1975, polychrome wood (13 1/2 x 14 3/4 x 8 13/16"), 92.17.84—CE

ALAN R. TSCHUDI, *Rarified Gas,* 1971, polychrome aluminum (61 3/16 x 90 1/8 x 89 9/16"), 92.17.85

JAMES TURNBULL (American, 1909-1976), *Filly,* brass (19 13/16 x 19 1/16 x 3 15/16"), 92.17.86

JAMES TURNBULL (American, 1909-1976), *Pelican,* brass and enamelled copper (9 7/8 x 9 7/8 x 4 13/16"), 92.17.87

NINA WINKEL (American, b. Germany, 1905), *Joy,* bronze (12 5/8 x 13 x 19 3/4"), 92.17.88—CE

ART GLASS:

BACCARAT GLASSWORKS, *Decanter,* Amberina glass (8 1/8 x 3 9/16")

CAMBRIDGE GLASS COMPANY, *Candlestick,* molded glass (8 1/4 x 4"), 92.17.89—E

CAMBRIDGE GLASS COMPANY, *Candlestick,* molded glass (9 13/16 x 4 7/16"), 92.17.90—E

CINCINNATI ARTISTIC WROUGHT IRON WORKS (?), *Hanging Dome,* glass and brass (15 1/8 x 23 3/4"), 92.17.151

DAUM BROTHERS, *Scent Bottle,* cameo glass, sterling silver and silverplate (7 x 3 x 2 7/16"), 92.17.91—CE

DAUM BROTHERS, *Covered Box,* cameo glass (2 1/2 x 3 7/16 x 3 7/16"), 92.17.92—CE

DAUM BROTHERS, *Table Lamp,* acid-etched glass, enamel and brass (11 1/8 x 4 1/4"), 92.17.93—CE

DAUM BROTHERS, *Vase,* cameo glass (7 x 4 11/16 x 3 9/16"), 92.17.94—CE

DAUM BROTHERS, *Vase,* 'Berluze' acid-etched glass (7 1/8 x 2"), 92.17.153—CE

ANDRÉ DELATTE, *Vase,* cameo glass (8 5/8 x 7"), 92.17.95—CE

DE VEZ (PANTIN GLASSWORKS), *Vase,* cameo glass (7 3/4 x 4 9/16"), 92.17.96—CE

FENTON ART GLASS COMPANY, *Candlestick,* molded glass (10 3/8 x 4 3/4"), 92.17.97

FENTON ART GLASS COMPANY, *Candlestick,* molded glass (8 13/16 x 4 3/8"), 92.17.98—E

H. C. FRY GLASS COMPANY, *Candlesticks,* glass (10 7/16 x 4 7/16 and 10 5/8 x 4 3/8"), 92.17.99.1-.2

G.F., *Flower-form Vase,* 1980, blown glass (6 11/16 x 4 3/16")

EMILE GALLÉ, *Bowl,* cameo glass (1 13/16 x 7 5/16 x 5 9/16"), 92.17.101—CE

EMILE GALLÉ, *Vase,* cameo glass (5 1/4 x 2 1/8"), 92.17.100

EMILE GALLÉ, *Vase,* cameo glass (3 5/8" x 1 9/16"), 92.17.102

EMILE GALLÉ, *Vase,* cameo glass (6 9/16 x 3 1/4 x 2 3/8"), 92.17.103

EMILE GALLÉ, *Vase,* cameo glass (8 7/8 x 2 11/16 x 1 3/4"), 92.17.104—CE

EMILE GALLÉ, *Vase,* cameo glass (5 5/8 x 3 7/16"), 92.17.105—CE

EMILE GALLÉ, *Stick Vase,* cameo glass (17 1/2 x 6 3/8"), 92.17.106—CE

EMILE GALLÉ, *Vase,* cameo glass (13 3/4 x 6 3/4"), 92.17.107—CE

LOETZ OF AUSTRIA, *Vase,* glass (8 7/8 x 3 7/16")

MOUNT WASHINGTON GLASS COMPANY, *Bottle,* cut velvet glass and sterling silver (4 5/8 x 3"), 92.17.108

MOUNT WASHINGTON GLASS COMPANY or NEW ENGLAND GLASS COMPANY,
Punch Cup, optic mold-blown Amberina glass (2 9/16 x 3 1/2 x 2 5/8"), 92.17.109—CE

MOUNT WASHINGTON GLASS COMPANY, *Vase,* Burmese glass (7 3/16 x 5 1/2"), 92.17.110—CE

MULLER BROTHERS, *Vase,* cameo glass (16 3/16 x 7 13/16"), 92.17.111—CE

NEW ENGLAND GLASS COMPANY, *Syrup Pitcher* (on underplate), Plated Amberina glass and silverplate (5 7/8 x 5 5/8"), 92.17.112—CE

NEW ENGLAND GLASS COMPANY, *Tumbler,* Plated Amberina glass (3 5/8" x 2 1/2"), 92.17.113—CE

NEW ENGLAND GLASS COMPANY, *Lemonade Tumbler,* Plated Amberina glass (4 3/4 x 3 1/16 x 2 7/16"), 92.17.114—CE

NEW ENGLAND GLASS COMPANY, *Lily Vase,* Plated Amberina glass (8 15/16 x 3 7/16"), 92.17.115—CE

NEW ENGLAND GLASS COMPANY, *Lily Vase,* Peach Blow glass (9 3/8 x 3 7/8"), 92.17.116—CE

NORTHWOOD GLASS COMPANY, *Candlestick,* molded glass (8 5/8 x 4 7/16"), 92.17.117—E

PAIRPOINT MANUFACTURING COMPANY, *Table Lamp,* glass and brass (21 1/2 x 14 5/8"), 92.17.118—E

QUEZAL ART GLASS AND DECORATING COMPANY (?), *Floor Lamp,* glass and bronze (50 7/8 x 13 5/8 x 11 1/2"), 92.17.134

ST. LOUIS GLASSWORKS COMPANY, *Vase,* cameo glass (2 9/16 x 5 3/4"), 92.17.119

STEUBEN GLASSWORKS, *Candlestick,* Gold Aurene glass (3 11/16 x 4 1/16"), 92.17.120—CE

STEUBEN GLASSWORKS, *Candlestick,* Blue Aurene glass (4 1/8 x 3 9/16"), 92.17.121

STEUBEN GLASSWORKS, *Candlestick,* Blue Aurene glass (10 x 4 9/16"), 92.17.122—CE

STEUBEN GLASSWORKS, *Fan Vase,* optic mold-blown glass (8 7/16 x 6 15/16 x 3 7/8"), 92.17.123—CE

LOUIS COMFORT TIFFANY, *Floraform Bowl,* Favrile glass (3 13/16 x 5 1/8"), 92.17.124—CE

LOUIS COMFORT TIFFANY, *Finger Bowl,* Favrile glass (2 3/16 x 6 5/16"), 92.17.128—CE

LOUIS COMFORT TIFFANY, *Bowl,* Favrile glass (2 5/16 x 4 1/2"), 92.17.129—CE

LOUIS COMFORT TIFFANY (TIFFANY STUDIOS), *Candlestick,* reticulated glass and bronze (17 1/8 x 5 7/16"), 92.17.125—CE

LOUIS COMFORT TIFFANY (TIFFANY STUDIOS), *Candlestick,* Favrile glass and gilded bronze (24 x 5 3/4"), 92.17.126—CE

LOUIS COMFORT TIFFANY (TIFFANY STUDIOS), *Zodiac Desk Set* [13 pieces: scales (3 1/2 x 1 7/8 x 3"), inkwell (2 1/8 x 4 1/16 x 4 1/8"), pen tray (3/8 x 10 1/8 x 3 3/16"), paperweight calendar (1 1/2 x 4 1/2 x 3 3/8"), paper clip (1 3/8 x 2 3/4 x 4"), paper rack (6 3/16 x 9 9/16 x 2 7/16"), rocker blotter (2 1/8 x 5 9/16 x 2 13/16"), memorandum pad (1/2 x 4 11/16 x 7 1/2"), paper knife (3/8 x 10 7/16 x 1"), blotter ends (3/8 x 2 x 19 1/4" each), utility box (1 x 5 3/8 x 3 1/2"), lamp (13 3/16 x 8 15/16 x 7")], gilded bronze, 92.17.143.1-.13—CE

LOUIS COMFORT TIFFANY (TIFFANY STUDIOS), *Dish,* gilded bronze (1 5/16 x 9"), 92.17.127

LOUIS COMFORT TIFFANY (TIFFANY STUDIOS), *Pond Lily Table Lamp,* glass and bronze (18 15/16 x 13 9/16"), 92.17.130—CE

LOUIS COMFORT TIFFANY (TIFFANY STUDIOS), *Table Lamp,* glass and bronze (19 7/8 x 12 1/2 x 8"), 92.17.131—CE

LOUIS COMFORT TIFFANY (TIFFANY STUDIOS), *Table Lamp,* glass and bronze (14 13/16 x 9 1/2"), 92.17.132

LOUIS COMFORT TIFFANY (TIFFANY STUDIOS), *Floor Lamp,* glass and bronze (57 7/8 x 13 5/8 x 10"), 92.17.133

LOUIS COMFORT TIFFANY (TIFFANY STUDIOS), *Floor Lamp,* glass and bronze (54 11/16 x 12 1/4 x 19"), 92.17.135—CE

LOUIS COMFORT TIFFANY, *Perfumer,* glass (7 3/8 x 2 3/8"), 92.17.136

LOUIS COMFORT TIFFANY, *Floraform Vase,* glass (14 1/8 x 4 9/16"), 92.17.137—CE

LOUIS COMFORT TIFFANY, *Floraform Vase,* glass (12 3/16 x 5 1/8"), 92.17.140—CE

LOUIS COMFORT TIFFANY, *Vase,* glass (1 3/4 x 1 9/16"), 92.17.138

LOUIS COMFORT TIFFANY, *Vase,* glass (2 13/16 x 2 3/16"), 92.17.139—CE

LOUIS COMFORT TIFFANY, *Vase,* glass (11 1/8 x 3 13/16"), 92.17.142

TIFFIN GLASS COMPANY, *Candlestick,* molded glass (8 1/16 x 4"), 92.17.144—E

TIFFIN GLASS COMPANY, *Candlestick,* molded glass (8 3/4 x 4 5/8"), 92.17.145

UNKNOWN, *Candlestick,* blown glass (8 3/16 x 3 11/16"), 92.17.146

UNKNOWN, *Cracker Jar,* glass and silverplate (6 1/8 x 5 9/16"), 92.17.147

UNKNOWN (Loetz-type), *Inkwell,* glass and gilded bronze (2 1/8 x 5 5/16"), 92.17.148

UNKNOWN, *Letter Box,* glass (4 5/8 x 7 1/4 x 4 5/16"), 92.17.149—E

UNKNOWN, *Pitcher,* optic mold-blown Amberina glass (8 5/8 x 6 5/8 x 5 7/16"), 92.17.150

UNKNOWN (probably English), *Vase,* glass (12 3/16 x 7 11/16"), 92.17.152

UNKNOWN, *Vase,* glass (18 x 7 1/4"), 92.17.141

VARIOUS MAKERS, *Candlesticks* (21), molded glass (from 1 5/8 x 3 13/16" to 9 1/4 x 4 5/8")

LE VERRE FRANÇAIS, *Vase,* cameo glass (7 7/8 x 5 1/8"), 92.17.154—CE

THOMAS WEBB AND SONS, *Bottle,* cameo glass and silverplate (4 5/16 x 3 15/16"), 92.17.155

ORIENTAL DECORATIVE ARTS:

CHINESE *Bowl,* 19-20th century, glazed ceramic (3 5/8 x 8 1/8")

CHINESE, probably Ch'ing Dynasty (1644-1912), *Two Entwined Chimeras,* jade with wood stand (3 x 3 13/16 x 3/8"; stand: 2 1/2 x 4 3/16 x 1 7/16"), 92.17.170—CE

CHINESE, *Decorative Egg,* cloisonné (2 7/16 x 1 11/16"; base: 3/4 x 1 3/8")

CHINESE, *Incense Burner,* 19th century, brass (1 3/4 x 9 7/16 x 2 1/4"), 92.17.172—CE

CHINESE, *Incense Clock,* 19th century, white copper and brass (2 13/16 x 11 5/8 x 3 1/8"), 92.17.173—CE

CHINESE, *Water Pipe,* 19th century, white copper (10 3/16 x 4 1/16 x 1 1/2"), 92.17.174

CHINESE, *Canton Famille Rose Plate,* 19th century, porcelain with overglaze enamels (7/8 x 5 7/8"), 92.17.39—E

CHINESE, *Coromandel 8-panel Floor Screen,* 1840, carved, painted and lacquered wood (84 1/8 x 128 x 3/4"), 92.17.17—CE

CHINESE, probably Ch'ing Dynasty (1644-1912), *Teapot,* Yixing stoneware (3 11/16 x 7 3/8 x 4 1/4"), 92.17.56

CHINESE, probably Ch'ing Dynasty (1644-1912), *Teapot,* Yixing stoneware (4 1/8 x 8 1/4 x 5 3/16"), 92.17.57—CE

JAPANESE, *Flower-arranging Basket,* woven bamboo (17 x 8 3/8"), 92.17.178

JAPANESE, Edo period (1615-1868), *Kettle,* cast iron (9 9/16 x 7 7/8 x 5 3/4"), 92.17.175—CE

JAPANESE, Edo period (1615-1868), *Kettle,* cast iron (8 13/16 x 7 x 5 5/8"), 92.17.176

AMERICAN DECORATIVE ARTS:

AMERICAN, Amish, *Quilt,* 1902, pieced cotton (72 1/2 x 88 1/2"), 92.17.169—CE

AMERICAN, Unknown, *'Bad Accident' Mechanical Bank,* polychrome cast iron (5 7/8 x 10 x 3 3/8")

AMERICAN, Unknown, *Building Still Bank,* polychrome cast iron (3 1/16 x 3 5/16 x 3 5/8")

AMERICAN, Unknown, *Man Milking a Cow Mechanical Bank,* polychrome cast iron (5 1/8 x 9 5/8 x 3 1/2"), 92.17.163—E

AMERICAN, Unknown, *Standing Man Still Bank,* polychrome cast iron (5 1/2 x 2 7/8 x 2 1/16")

AMERICAN, Unknown, *Tammany Mechanical Bank,* 1873, polychrome cast iron (5 3/4 x 3 7/16 x 4 5/8")

AMERICAN, Unknown, *Candlestick,* brass (3 3/4 X 5 7/16 X 4 1/2")

AMERICAN, Unknown, *Cheese Strainer,* glazed ceramic (15 1/2 x 8 1/8")

AMERICAN, Unknown, *Coverlet,* mid-19th century, natural cotton and dyed wool (86 1/8 x 77 1/4"), double cloth technique woven on a hand loom with Jacquard attachment, 92.17.168—CE

AMERICAN, Unknown, *Cow,* polychrome wood (3 9/16 x 7 1/8 x 1 15/16"), 92.17.156—CE

AMERICAN, Unknown, *Crow,* polychrome wood (8 1/16 x 2 1/4 x 3 13/16"), 92.17.157—CE

AMERICAN, Unknown, *Duck Decoy,* polychrome wood (6 5/16 x 12 7/8 x 4 9/16")

AMERICAN, Unknown, *Eagle,* wood (15 x 22 1/4 x 3 3/8")

AMERICAN, Unknown, *Man at Machine from E.J. Shoe Co. ('Efficiency in the Rough'),* wood (7 5/8 x 13 7/8 x 8"), 92.17.158—CE

AMERICAN, Unknown, *Pioneers in a Conestoga Wagon,* polychrome wood, fabric, and metal (12 x 27 11/16 x 8 3/4"), 92.17.159—CE

AMERICAN, Unknown, *Rooster,* polychrome wood (7 13/16 x 5 3/4 x 2 3/16"), 92.17.160—E

AMERICAN, Unknown, *Rooster,* polychrome wood (4 11/16 x 4 15/16 x 1"), 92.17.161

AMERICAN, Unknown, *Seated Man and Woman with Paddle Toy,* polychrome wood and metal (17 1/4 x 12 1/4 x 7 1/16"), 92.17.162—CE

AMERICAN, Unknown, *Stagecoach,* polychrome wood and metal (6 3/4 x 20 13/16 x 6 5/8"), 92.17.165—E

AMERICAN, Unknown, *Horse-Drawn Fire Engine Toy,* polychrome cast iron (7 1/16 x 19 3/4 x 5 5/8"), 92.17.166—CE

AMERICAN, Unknown, *Toy Stove,* cast iron (16 3/8 x 18 3/8 x 8 1/8"), 92.17.164—E

AMERICAN, Unknown, *Trotting Horse Weather Vane,* copper (17 3/16 x 23 x 1 7/16")

AMERICAN, Unknown, *Hunting Dog Weather Vane,* polychrome ferrous metal (40 1/2 x 45 15/16 x 2"), 92.17.167—CE

AMERICAN, Unknown, *Eagle Weather Vane,* polychrome copper, wood and iron (34 1/8 x 23 5/8 x 26 1/2")

AMERICAN, Unknown, *Man Sawing a Log Whirligig,* polychrome wood and metal (9 11/16 x 28 1/8 x 2 1/2"), 92.17.180

AMERICAN, Unknown, *Running Horse Whirligig,* wood, metal and leather (17 1/2 x 26 1/8 x 5 11/16"), 92.17.181—E

AMERICAN, Unknown, *Two Men Turning a Propeller Whirligig,* polychrome wood and metal (15 1/2 x 13 11/16 x 5 13/16"), 92.17.182—E

AMERICAN, Unknown, *Two Men Operating Machinery Whirligig,* polychrome metal and wood (12 3/8 x 14 5/8 x 7 1/2"), 92.17.183—E

AMERICAN, Unknown, *Man Sawing a Log near a Tree Whirligig,* polychrome wood and metal (14 7/8 x 16 5/8 x 12 1/8"), 92.17.184

KENNETH BATES (American, b. 1904), *Dish,* 1958, enamelled copper (5/8 x 13 7/8 x 3 5/8"), 92.17.51

CHANDLER, *Dish,* enamelled copper (3 x 22 7/8 x 6 1/8")

FAIRCHILD, *Pen Holder,* gold-finished metal (1/4 x 5 9/16 x 5/16")

ROLLAND LIETZKE (American), *Vase,* unglazed ceramic (8 1/8 x 4 1/4 x 4 3/8"), 92.17.68

MARY ELLEN MCDERMOTT (American), Untitled, enamelled copper (6 3/8 x 55 1/8"), 92.17.69

VIKTOR SCHRECKENGOST (American, b. 1906), *Vase,* glazed ceramic (20 x 6 11/16"), 92.17.81

CHESS SETS:

AFRICAN, probably Mokkondi, *Chess Set,* 20th century, wood (ranging from 4 5/16 x 1 1/16" to 6 11/16 x 1 1/2 x 1 9/16"), 92.17.185.1-.32—E

CHINESE, *Chess Set,* probably 20th century, ivory (ranging from 1 13/16 x 1 1/4 x 9/16" to 3 15/16 x 1 1/8 x 3/4"), 92.17.186.1-.32

CHINESE, *Chess Set,* probably 20th century, jade and nephrite (ranging from 2 1/4 x 15/16 x 1" to 3 1/8 x 1 x 15/16"), 92.17.187.1-.32

CHINESE (Anglo-Chinese style, Burma), *Chess Set,* 19th century, ivory (ranging from 3 x 1 5/16" to 1 1/2 x 7/8"), 92.17.188.1-.32—E

ENGLISH (Barleycorn style), *Chess Set,* 19th century, ivory (ranging from 1 7/16 x 7/8" to 4 x 1 1/8"), 92.17.189.1-.32—E

FRENCH (Dieppe style), *Chess Set,* probably 18th century, polychrome ivory (ranging from 1 5/8 x 1 1/16" to 2 7/8 x 1 1/16"), 92.17.190.1-.32—CE

ITALIAN, *Chess Set,* 20th century, composition (ranging from 2 1/4 x 1 3/8" to 3 5/8 x 1 3/8"), 92.17.191.1-.32

JAPANESE, *Chess Set,* 20th century, ivory (ranging from 1 7/16 x 11/16" to 2 5/16 x 1 1/8 x 15/16"), 92.17.192.1-.32—E

JAPANESE, *Chess Set,* 20th century, ivory (ranging from 1 1/2 x 7/8" to 2 7/16 x 1 1/16"), 92.17.193.1-.32

MEXICAN (Tarascan Indian style), *Chess Set,* ca. 1940, polychrome, inlaid wood and ivory (ranging from 1 9/16 x 1 1/4" to 4 x 1 1/2"), 92.17.194.1-.32

MEXICAN (Pulpit style), *Chess Set,* 19th century, ivory (ranging from 2 5/8 x 1 3/16" to 5 3/8 x 1 7/16"), 92.17.195.1-.32

SPANISH, *Chess Set* (Bullfight motif), 20th century, polychrome wood (ranging from 2 x 15/16" to 3 5/8 x 1 3/8 x 1 3/16"), 92.17.196.1-.32

STEUBEN GLASSWORKS, *Chess Set,* 20th century, molded glass (ranging from 1 13/16 x 15/16" to 3 x 1 1/4"), 92.17.197.1-.32—CE

UNKNOWN, *Chess Set,* handmade glazed ceramic (ranging from 1 3/8 x 13/16 x 13/16" to 3 x 1 7/16 x 1 7/16"), 92.17.198.1-.32

UNKNOWN, *Chess Set,* nephrite (ranging from 1 1/4 x 13/16" to 2 9/16 x 1"), 92.17.199.1-.32

UNKNOWN, *Chess Set,* 20th century, brass and steel (ranging from 1 3/16 x 11/16" to 2 x 7/8"), 92.17.200.1-.31

UNKNOWN, *Assorted Chess Pieces,* ivory, bone and jade (ranging from 1 x 13/16" to 1 11/16 x 11/16"), 92.17.201.1-.12

U.S.S.R.(?), *Chess Set* (Slavic peasant motif), 20th century, polychrome wood (ranging from 1 7/16 x 3/4" to 3 1/16 x 1 1/16"), 92.17.202.1-.32

MISCELLANEOUS DECORATIVE ARTS:

ENGLISH, *Battersea Box (Racing),* hand-painted enamelled brass (1 3/16 x 2 3/8 x 1 9/16"), 92.17.177

GERMAN(?), Unknown, *Horse and Cart Toy,* polychrome wood and metal (5 13/16 x 13 1/2 x 4 7/16")

IRANIAN, *Vase,* glazed ceramic (7 1/2 x 4 1/8")

UNKNOWN, *Battle Stick,* steel (2 7/8 x 27 x 2 15/16")

UNKNOWN, *Cart and Horse with Driver Toy,* polychrome cast iron (2 11/16 x 5 1/2 x 2 5/16")

UNKNOWN, *Hippo,* wood (4 5/16 x 15 11/16 x 4 5/16")

UNKNOWN, *Hobby Horse,* polychrome wood and jute (14 1/16 x 14 1/16 x 4 5/8")

UNKNOWN, *Horse and Wagon,* brass, copper and silverplate (4 3/4 x 8 3/16 x 2 3/4"), 92.17.179

UNKNOWN, *Horses with Bells Toy,* polychrome cast iron and steel (3 x 4 3/16 x 4 11/16")